IMAGES
of America

BLOOMINGDALE

IMAGES
of America

BLOOMINGDALE

Annamarie Erickson and Mary Ellen Johnson

ARCADIA
PUBLISHING

Published by Arcadia Publishing
Charleston SC, Chicago IL, Portsmouth NH, San Francisco CA

Printed in the United States of America

Library of Congress Catalog Card Number: 2007940133

For all general information contact Arcadia Publishing at:
Telephone 843-853-2070
Fax 843-853-0044
E-mail sales@arcadiapublishing.com
For customer service and orders:
Toll-Free 1-888-313-2665

Visit us on the Internet at www.arcadiapublishing.com

For those who lived it:
Bloomingdale residents past and present

CONTENTS

ACKNOWLEDGMENTS

The impetus for this Arcadia publication came from the Bloomingdale Historical Society. It is the respect and appreciation the members have for those who came before us that made this book a labor of love. Most of the pictures and documents used were provided by the local history room in the Bloomingdale Public Library. Other sources are noted.

Special recognition goes to Bonnie Homola, president of the Bloomingdale Historical Society. Without her encouragement, organizational skills, and immersion in this project, the book could not have come together. We also need to thank the following members of the organization who graciously shared their time to research, follow leads, seek out photographs, write, proof, and encourage: Chuck and Marsha Franzen, Georgene Geils, Diane McLaughlin, Madonna Randecker, Emil Zidek, and Bob Kurek for his extensive knowledge on the Civil War.

Our gratitude also goes to the staff of the Bloomingdale Public Library for their unconditional help and access to files needed to gather the material for this publication. The library has always been a tremendous partner in our endeavors and this, our biggest project to date, was no exception.

We must give credit to John Pearson and Jeff Ruetsche of Arcadia Publishing. Their guidance, encouragement, and patience throughout this project were invaluable to our success. And lastly, we are grateful to our families—Annamarie Erickson's children, Caroline and Clarence, and Mary Ellen Johnson's husband, Paul, and children. Their faith in us, as well as their patience and understanding while we were engrossed in this project made this undertaking possible.

INTRODUCTION

It is likely everyone's hope to leave a mark and to be a part of the fabric that tells the story of a family, a place, or a time. So much ends up in boxes in the attic or a closet, tucked away and forgotten.

When the Meacham brothers arrived in what is now known as Bloomingdale, they were looking for a future—a place where their families could flourish. Those who followed had the same intent. And so slowly but surely, those early pioneers grew the town of Meacham's Grove around them. Some made a mark and then moved on. Others were in it for the long haul. This book is about many of them and the town that came from their efforts.

Once platted in 1845 as Bloomingdale, development began in earnest. The settlers created roads, formed churches, established schools, began businesses, and farmed the land. They moved forward. By the 1870s, the area still known as Bloomingdale was expanding. However, the northeast section of town was taking on a separate identity because of two men who wished to have their land be platted as Roselle. Rosell Hough was instrumental in getting the Chicago, Milwaukee and St. Paul Railroad line to stop in Roselle in 1873 and the course of Bloomingdale's growth was sidetracked.

Bloomingdale was incorporated in 1889, yet the area known as Roselle remained called "the northeast end of Bloomingdale." Even so, in 1904, a library was established for $200 that spent half its time in Bloomingdale and half in Roselle. A fire truck was also purchased that was split between the two towns.

The population in Bloomingdale in 1910 before Roselle separated from Bloomingdale was 462. The population never surpassed 400 until 1950 as the community remained largely agricultural. It was not until 1960 that the first inkling of the population explosion appeared. The building boom was around the corner. As the community grew, Bloomingdale planned for its own library, and a park district was formed.

Subdivisions sprung up; two more schools were built. A golf course overtook a sod farm, then a hotel enveloped the golf course and a resort filled the landscape on the south side of Schick Road. The farms were disappearing. A regional mall developer approached village officials and it began a new time in Bloomingdale, which included a strong financial position and new opportunities for planned commercial growth.

A few of the buildings from the 19th century still exist in Bloomingdale. The Old Town area near the intersection of Lake Street and Bloomingdale Road is designated a historic preservation district. There are reminders. But this book—dedicated to the residents of Bloomingdale, past and present—holds many of those memories that can no longer be seen. May both the residents and the memories not be forgotten.

One

THE BEGINNING
1832–1870

Under the command of Winfield Scott, Army Trail Road was blazed by Col. Zachary Taylor in 1832 during the Blackhawk War. Army Trail Road leads from Chicago to Addison to west of the Fox River, and on to Beloit, Wisconsin. The tracks that were left in the ground by the heavy U.S. Army wagons created a road for early settlers traveling west. It was this road that brought the first settlers, the Meacham brothers, to the Bloomingdale area. When they claimed their 1,200 acres in 1833, they named the area Meacham Grove. The marker displayed in this photograph was erected in the Addison, Illinois, municipal center. (Courtesy of the Addison Historical Society.)

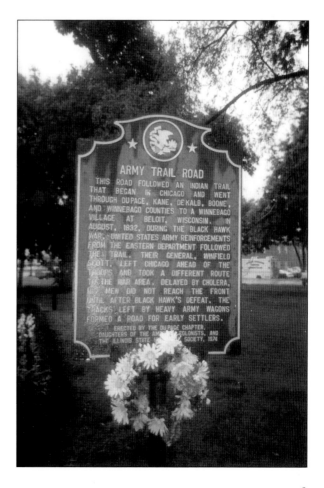

(Copy of a letter from Huldah Cody to her sister Mrs. David
Rogers. The original of this letter is owned by H.S.Cody of
Winston-Salem, North Carolina.)

 (Bloomingdale, Ills.)
 September 29, 1844.

Mrs. David Rogers,
Eaton,
Madison Co.
New York.

Dear Sister:-
 to
 It is not long since I wrote/all of you, but hav-
ing an opportunity to send as far as Rome I thought I would
write again. A Mr. Hull and Rathbone are here looking at the
country and going back this fall. A brother of Mr. Rathbone's
has been building here this summer. They live in the house
with Frisbie till theirs is completed. It is quite cool weather
now and you cannot think what a hurrying there is to get fixed
up for winter. It was so cold yesterday Hiram had to bring his
bench downstairs. Could not keep warm by the stovepipe. Their
shop is nearly finished and they expect mean to go into it to-
morrow. We have about given up plastering this fall and it will
be so difficult when we are in it, but we shall have it warm. We
have tight matched floors and Hi has brought brick for a dollar
thousand to fill up and has got his lime ready to do it. This we
wanted to do if he plastered for as I think quite likely when that
is done it will answer for the winter. The size of the shop is
14 by 20. The back part of it has a bedroom for Hiram and is an
excellent little building. Our house is only 2 feet each way larger
making us a room 16 by 14 except a jog for chamber, stairs, under
which we have done a cupboard. Our bedroom 8 by 10 the other 7 by
8. In the large one we put the turnup bedstead and lounge and a
carpet on it, making quite a little sitting room, but the chambers
are very pretty. The end towards the road where they have worked
this summer has 2 windows in it and will make a very pretty room,
nearly as large as the kitchen. There is room in the other for 2
beds, some chests, etc. I should have had one bedroom done off in
a buttery, but we intend to have some kind of a kitchen for work
and a buttery with that next spring if not before. For cellar they
have dug a place under their shop for this winter intending to have
a Chicago cellar out of our back door, which is done by digging a
very little and then building with brick and covering with earth.
We shall have accomplished more this fall, but the going has been
so bad through the slough that it would have cost too much to have
got things drawn. Now the going is good and everyone is improving
it. The road a mile and a half north of us is traveled the most as
thisroad has not been worked much through the summer, but there
is a great deal of travel by here. One hundred and 35 waggons have
been counted passing that road in a day, which is nothing unusual.
I mean in this letter to write all the little things so you can
think pretty much how we are. I suppose you know what I mean by
filling up with brick. Cordelia says E. M'Connel talked of filling
up in the same way. I am going to mark out as near as I can our
situation here. The distance will be about 4 miles each way. I shall
number some places and explain below.

Hiram H. Cody arrived in Meacham's Grove in 1843, a shoemaker by trade. He soon had a great
business as many a foot traveler was in need of shoe repair. He became a prominent citizen,
serving as a businessman, postmaster, and innkeeper in Meacham's Grove. One of the re-created
buildings in Bloomingdale's Old Town area is named Cody's Hotel in honor of the early hostelry.
Cody, who was a distant relation to Buffalo Bill Cody, moved on to Naperville, Illinois, and
became Judge Hiram H. Cody. This is a copy of an excerpt from a letter written in 1844 by his
wife, Huldah, to her sister, Mrs. David Rogers, in New York. Huldah provides a good description
of her home, in addition to describing the life of settlers in this fledgling town.

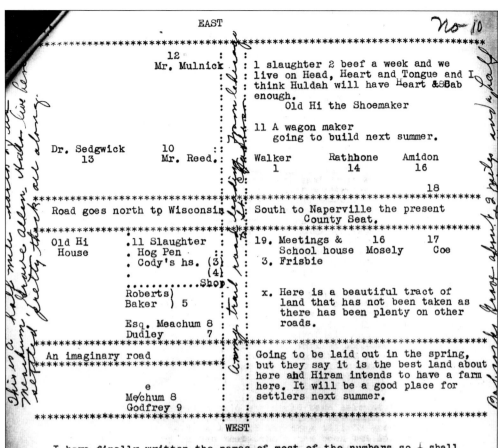

EAST

```
                    12      :
                  Mr. Mulnick     :   1 slaughter 2 beef a week and we
                                  :   live on Head, Heart and Tongue and I
                                  :   think Huldah will have Heart &Bab
                                  :   enough.
                                  :        Old Hi the Shoemaker

                                  :   11 A wagon maker
                                  :      going to build next summer.

Dr. Sedgwick        10         ::
    13            Mr. Reed.:  :   Walker      Rathbone      Amidon
                                  :     1          14           16

                                  :                                18
*********************************  *********************************
Road goes north to Wisconsin      South to Naperville the present
                                             County Seat.
*********************************  *********************************
Old Hi        .11 Slaughter   :   19. Meetings &        16        17
House         . Hog Pen       :       School house   Mosely      Coe
              . Cody's hs. (3):   3. Frisbie
              .          (4)
              ...........Shop  :
              Roberts)            x. Here is a beautiful tract of
              Baker  ) 5             land that has not been taken as
                                     there has been plenty on other
              Esq. Meachum 8 :       roads.
              Dudley       7 :
*********************************  *********************************
An imaginary road                 Going to be laid out in the spring,
*********************************  but they say it is the best land about
                                  :  here and Hiram intends to have a farm
                                  :  here. It will be a good place for
                 e                :  settlers next summer.
            Me/chum 8
            Godfrey 9
*********************************  *********************************
                              WEST
```

I have finally written the names of most of the numbers so ⊥ shall
not refer to them all. 18 is where I have not been. It is merely a mile
from us. There are 4 families there near to each other. One of them
manufactures tin and sheet iron. 19 is marked meeting house. That is
not built tho they think they shall do it this fall. x. Baker is Robert's
father-in-law. He is going to build where I made the cross a half mile
from us. 13. Dr. Sedgwick. I have marked a little too far from us as it
is not a half mile. 17. Coe has an excellent farm. His brother-in-law
has helped them a great deal so they are doing remarkably well. They
live about half mile. I walk there and to Mr. Amidon's sometimes. I
ride after oxen which ⊥ like very much. Our place No. 3, you see, does
not come quite ot the corner as Mr. Walker owns the land back of us and
wanted a building spot for that farm on the road.

You wished to know how we lived and I see Hi has written in part. We
have plenty of beef and tallow, 2 cows, the best hogpen we ever had with
2 hogs and 2 pigs in it. a Hen house on top and a house joining, which
everyone in Illinois don't have. We have plenty of eggs, pumpkins, and
dried apples for pies. Melon time is about over and I am glad of it
for there have been several very sick with summer complaint, but we have
been well and are so still. Oc ober 5. Since I wrotem Charles Graham has
had a billious attack, but I think will get along without a course of
fever. ⊥ have felt afraid it would be sickly it has been such an uncom-

Huldah also included a drawing of the area in which she lived in order to illustrate various locations within the town for her sister.

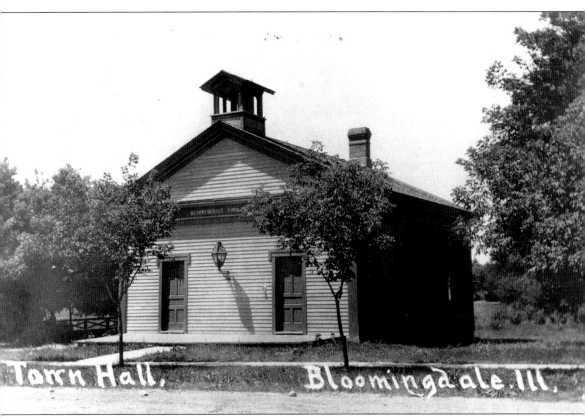

Meacham's Grove reached a milestone in 1845 as it became the third town to be platted in DuPage County. The plat shows 35 families living here. As more settlers arrived in Meacham Grove, they began to organize churches. The Baptist Society was organized at the home of Noah Stevens on March 24, 1841. Rev. Joel Wheeler and Rev. A. W. Bulton copastored in the beginning. Among the first members were Stevens, Waters Northrup, Hiram Goodwin, Ephraim Kettle, Asa Dudley, F. R. Stevens, Orange Kent, J. D. Kinne, Philo Nobles, Silas Farr, and William Farr. Goodwin purchased the lot at Franklin and Main Streets from Dr. Silas Meacham and his wife, Rebecca, for $1,100. He donated it for the church on May 20, 1844. Built in 1849 as the Baptist church, this structure remains one of the oldest existing structures in Bloomingdale. In later years, it was also used as a school, assessor's office, township building, park district office, and museum.

The Congregational Society of Bloomingdale was founded in 1840. The founding members included Elijah Hough, Allan Hills, C. H. Meacham, W. Dodge, A. Buck, E. Thayer, and J. P. Yaldingin. Rev. D. Rockwell was the first pastor. Hough was the father of Rosell Hough, for whom the village of Roselle was named. He remained with the Congregational Church as a deacon until his death in 1851. The Congregational church pictured at right was built in 1852 on First Street.

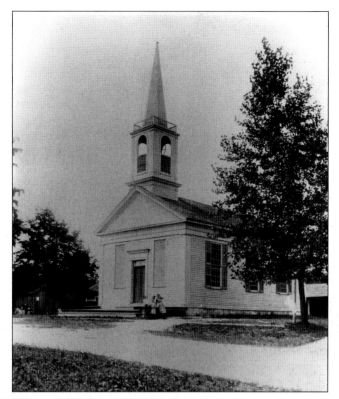

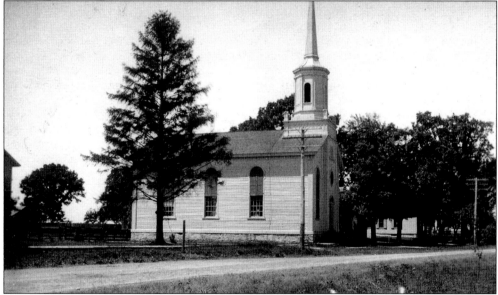

This Baptist church was built on the south side of Lake Street, west of Second Street (now Bloomingdale Road) in 1855 under the leadership of Reverend Taylor. It was from the steps of this building that it is rumored Abraham Lincoln spoke during his unsuccessful senatorial race against Stephen A. Douglas in 1858. Although this story has been proudly repeated over the years, it has never been proven. However, historians have never been able to disprove it either, so the tale persists.

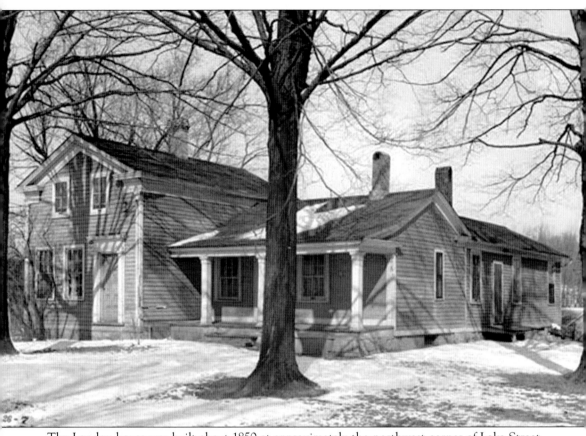

The Landon house was built about 1850 at approximately the northwest corner of Lake Street and Circle Avenue. Eventually the farmhouse became the Bender farm. In 1934, this house was selected by the Historic American Buildings Survey as an excellent example of Greek Revival farmhouse architecture. The turned-under corners of the eaves, the inviting side door, pillared porch, and more formal front door, which was seldom used, are characteristic of the style that prevailed in American domestic architecture from 1820 to 1850. The structure burned down in the 1950s. (Photograph by Chester Hart; courtesy of the Bender family.)

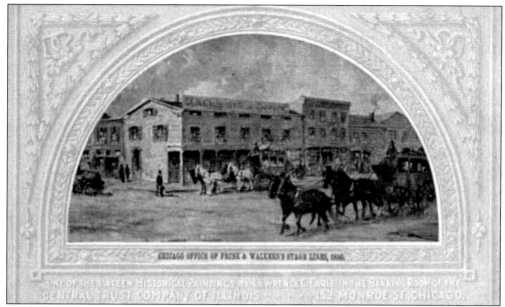

The Frink and Walkers stage line ran from Chicago to Elgin. A route came through Bloomingdale in 1836 thanks to the founders of Elgin, who staked out a trail to the nearest Chicago and Galena stagecoach stop just south of Meacham's Grove in 1835. This postcard, depicting the stage line, is one of the 16 historical paintings by Lawrence Earle that hung in the banking room of the Central Trust Company of Illinois at 152 Monroe Street in Chicago. The original paintings were destroyed in the Chicago fire of 1871.

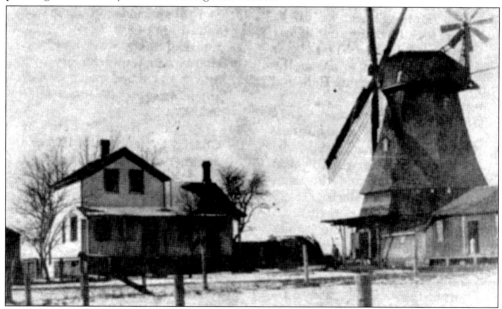

Henry Holstein and his wife Louisa emigrated from Germany in the 1850s. They purchased farmland in Bloomingdale on the west side of Bloomingdale Road, just south of Schick Road. Holstein built a windmill on his farm across from what is now the Village Hall complex. Area farmers would bring their grain to Holstein to be ground, and their tools to be sharpened, the latter saving them a 30-mile trip to Chicago. (Courtesy of Karen Umlauf.)

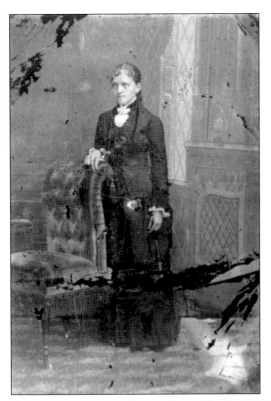

Caroline Jessie Clark married George Standish Meacham in 1858. He was the son of Harvey Porter Meacham, one of the original settlers. She died in July 1864 and is buried in the Hebron Cemetery in Nicolet County, Minnesota. The home in this photograph, which was located on the south side of Bloomingdale Road near First Street, belonged to George Standish Meacham. It is not known if the couple on the porch is Caroline and George.

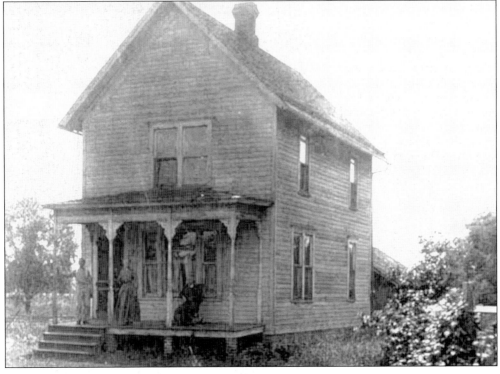

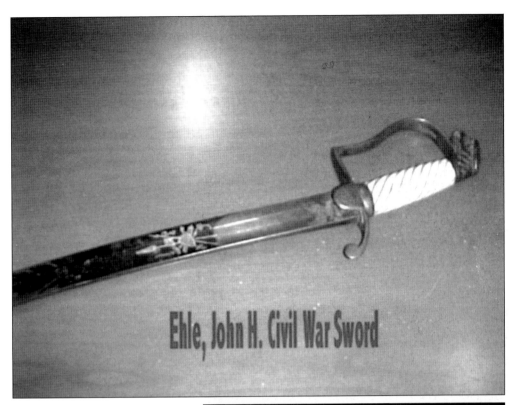

Ehle, John H. Civil War Sword

Resident John H. Ehle, father of eight, enlisted in 1861 at the age of 62, leaving his family behind. He owned a few acres around Fullerton Avenue and Bloomingdale Road. Ehle died of disease in 1862 and is buried in Alexandria National Cemetery in Virginia. He is one of the soldiers who have a memorial stone here in a family plot, although they are buried elsewhere. Two of Ehle's sons were also in the war. Austin served with his father in the 8th Illinois Cavalry and Harmon was in the 105th Illinois Infantry. John's original grave marker was replaced with the memorial stone pictured as part of the Bloomingdale Historical Society's project to replace damaged Civil War markers. The stones were provided by the Federal government. (Above, courtesy of Virginia Gary.)

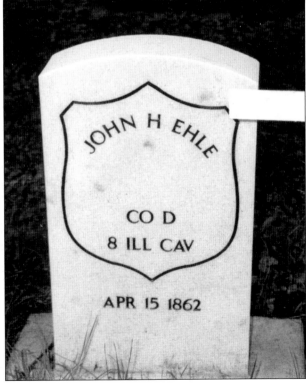

JOHN H EHLE

CO D
8 ILL CAV

APR 15 1862

CLASS	Age	NO.	CLASS	Age
58 John Himmel	36	91	Fred Marquodt	21
59 Frank Hewitt	25	92	Geo W Milner	24
60 John Hefesimer	25	93	Howard McDowell	22
61 Fred Holeman	37	94	Daniel Murphy	35
62 John A Hatch	42	95	George Wellingham	25
63 William Hatch		96		
64 John Howley	35	97	D S McGraw	44
65 John Hobler	44	98	Henry Muhling	25
66 Vanburen Hatch	19	99	Abraham Money	20
67 H B Hills	42	100	Fred Meyors	40
68 John Hisler	35	101	Frank Money	43
		102	Henry Meehler	21
69 John Kirk	35	103	L Motesker	18
70 Hiram Kelsey	28	104	John Medland	36
71 R B Kinney	26	105	Fred Meyers	25
72 John Holstedt	26	106	Henry Moore	44
73 Geo W Holstedt	31	107	Martin Minor	30
74 Charles Holstedt	28			
75 Henry Holstedt	24	108	George Nagle	42
76 William Hanson	26	109	Henry Nagle	27
77 Arthur Kinney	26	110	John Nettner	21
78 Henry Kretchmeyr	35	111	Beth P Nelwell	26
79 Henry Libbott	33	112	Michael O'Charay	40
80 George Lake	21	113	H C Oakman	38
81 Robt Lawrence	29	114	Fred Brolt	18
		115	Petrish	
82 Wm Marriott	36	116	James Pierce	22
83 Lucius Meacham	21	117	Wm Pierce	40
84 Henry Meacham	19	118	John Pierce	25
85 C H Moseley	43	119	W R Patrick	39
86 Wm Meyers	21			
87 Mark Minor				
88 Sewellen Minor	19			

In June 1863, the militia roll for the town of Bloomingdale listed 157 "free, white, male, able-bodied citizens between the ages of 18 and 45, subject to military duty." Many of those who joined the service in Bloomingdale entered the 8th Illinois Cavalry. This is the regiment that started the Battle of Gettysburg. The copy of the prisoner of war records below shows William B. Pierce was another young man who mustered into the 8th Illinois Cavalry. At the age of 25, he was captured and sent to Andersonville Prison, known as the "infamous Confederate hell hole." He was one of two DuPage County soldiers to die at the prison in Georgia. Livingston Gearhart, another resident, was captured several days after the Battle of Gettysburg and sent to Andersonville. He actually survived his years at the prison, but when he was finally paroled, the ship bringing him home, the *General Lyons*, was caught in a hurricane. Gearhart was lost at sea. (Courtesy of the National Archives and Records Administration.)

MEMORANDUM FROM PRISONER OF WAR RECORDS. No. _____

(This blank to be used only in the arrangement of said records.)

Peirce W B P 8 Illo C H

Captured at Brentsville Va Sept 14, 1863, confined at Richmond, Va., Sept 17, 1863. Sent to Andersonville Ga Much 21/64. Admitted to Hospital at Andersonville Ga where he died May 31, 1864, of Diarr. C. Paroled at ... Reg 7366

Gen. W T Ward — our Brigade
Commander was wounded in one
arm & lost his hat — but remained on
the field. Company F loss is —
Arthur P Rice killed in front of the
Rebel Foart — Lieutenant William
Tirtlott severely wounded — others
wounded are Harmon S Ehle — John
Mc Gilfrey — William Brown.
 Our Brigade is to bury the
dead & geather, the arms that are
on the battle field. Today when I
walked over the ground in front of the
Rebel works and saw how the brush
was cut down & the trees seared — I
wonderd that any of us escaped.
The Confederates were well trained
as they fired low — although they were
shooting down hill. General Johnston
moved his army over the river during
the night — the best thing he could do as
Gen. Sherman was closing in on
him. We of course will follow
him soon.

This is a page from the diary of Bloomingdale resident James A. Congleton, who enlisted in the army at the age of 19. He was mustered into Company F of the 105th Regiment Illinois Infantry Volunteers on September 2, 1862, as a private. The entry, dated May 16, 1864, and written in Georgia, begins on the previous page. Congleton explains the Union army is estimating the costs of their victory the day before. He says they judged 3,000 soldiers were killed, wounded, or taken as prisoners from each army. He goes on to write about the aftermath of the battle. Note at the end that Gen. William T. Sherman is mentioned as this is the early part of his Atlanta campaign that eventually led to the infamous Sherman's march to the sea. Also, in line eight, Harmon Ehle is mentioned as wounded. (Courtesy of DuPage Historical Museum.)

In 1860, the Bloomingdale Academy was formed with 75 students and two professors. In 1861, the Baptist Church sold the building at Bloomingdale Road and Franklin Street to the academy. Later that same year, School District 7 (later School District 13), purchased the structure and used it as a school until 1894. More than 100 years later during a park district rehabilitation project, the following items were uncovered in the structure: two 19th-century maps, bottles, an inkwell, and an almanac from the 1860s. Pictured is one of the maps discovered. (Courtesy of Bloomingdale Park District.)

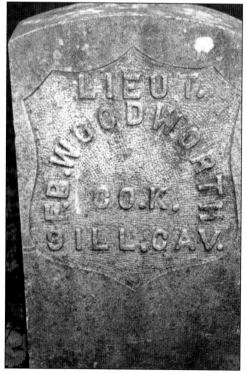

Elizabeth (Lizzie) Meacham, daughter of Benjamin Franklin Meacham, was a student at Wheaton College at the time of the Civil War and was on the committee to render assistance to the sick and wounded soldiers. A meeting was held on September 1, 1861, at the academy building, mentioned above. Lt. Frank Woodworth married Meacham in 1873. Woodworth was a veteran of the Civil War, a part of the 9th Illinois Calvary, Company K. He was promoted to second lieutenant on March 16, 1864. The Woodworths are buried in the B. F. Meacham family lot in the St. Paul Evergreen Cemetery.

Two

A TOWN EMERGES
1871–1910

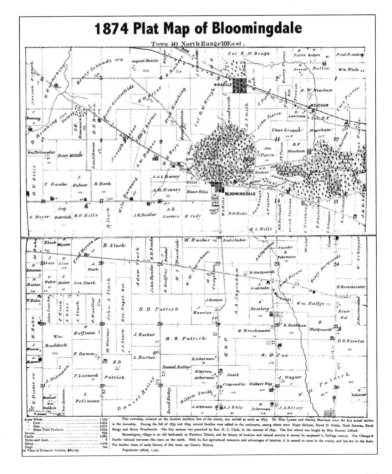

1874 Plat Map of Bloomingdale
Town 40 North Range 10 East.

On this 1874 plat, it is obvious that Bloomingdale and its surrounding area were largely farmland. However, there were several businesses operating within the boundaries of the village proper. Also on this map, Roselle is platted separately but is not yet officially recognized as a town.

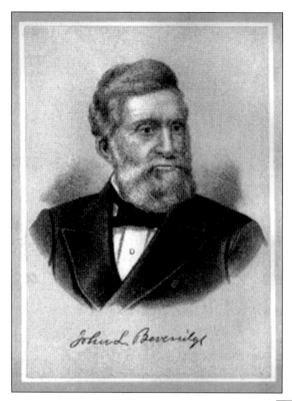

John L. Beveridge

On September 18, 1873, a reunion of the 8th Illinois Cavalry Regiment gathered in Bloomingdale at the wagon maker and blacksmith Robert Wales Gates's property on Second Street (later Bloomingdale Road). A large number of soldiers of the 8th Illinois Cavalry Regiment hailed from Bloomingdale. Also attending the event was John L. Beveridge, the 17th governor of Illinois. As a major in the war, Beveridge was their commander at Gettysburg. A member of the regiment fired the first shot in the Battle at Gettysburg.

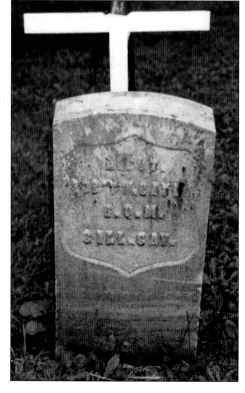

Robert W. Gates enlisted as a private in Company D, 8th Illinois Cavalry and served until the close of the Civil War. Six months after his enlistment he was promoted to quartermaster sergeant of the regiment. In the winter of 1863, he was promoted to first lieutenant and had charge of the quartermaster's department of his regiment. After his return, he had a successful wagon making and blacksmith business in Meacham's Grove. In 1874, he was elected justice of the peace, a position he held for more than one term. He is buried in St. Paul Evergreen Cemetery.

Col. Rosell Hough, son of early settler Elijah Hough, left Bloomingdale for Chicago in 1838, becoming a very successful businessman there. When he returned in 1868, he focused his interest toward the town. Bernard Beck, who owned land in the northeast section of Bloomingdale, had his property designated in 1873 as the "Roselle section of Bloomingdale," as a gesture to his good friend and neighbor, Hough. By 1875, Hough himself had accumulated some 300 acres near the intersection of State and Chicago Streets (currently Roselle and Irving Park Roads, respectively). When platted, he requested his property also be called Roselle. The photograph to the right is a portrait of Hough made after the Civil War. Pictured below is part of his property in Roselle. The home still stands not far from the northeast corner of Roselle and Irving Park Roads. (Courtesy of the Roselle Historical Foundation.)

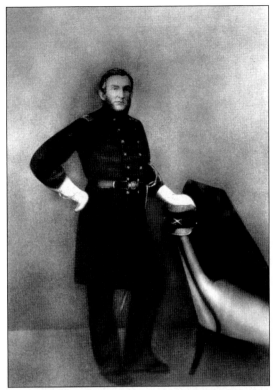

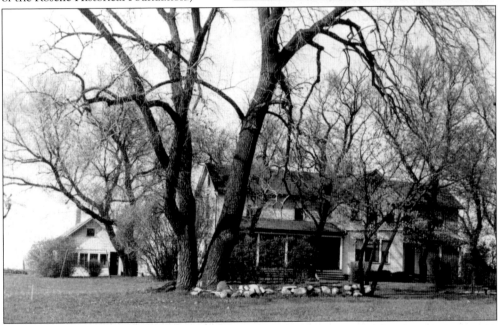

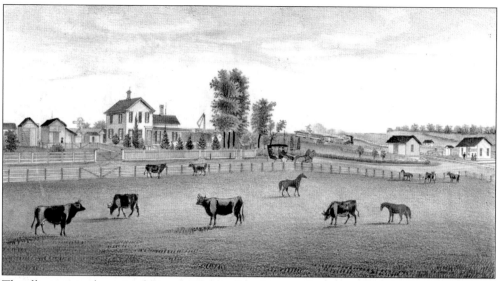

The illustration above is of George W. Meacham's estate from the 1894 Atlas and History of DuPage City. The son of Benjamin Franklin and Rebecca Meacham moved to the area now known as Medinah and became the first postmaster there. The town was named Meacham after him. In 1873, he donated the land for the post office and for a Meacham station for the Chicago, Milwaukee and St. Paul Railroad line. The photograph below is of the house as it looks today. A look at the location of both the train station and post office today in relation to the site of the home illustrates how vast Meacham's property was. When his father passed away in 1879, the younger Meacham sold the family estate and moved to Chicago.

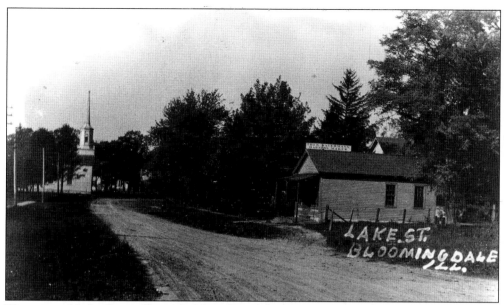

This view of Lake Street (formerly Main Street) looking west around 1874 shows the Baptist church in the distance and the harness shop of Thomas Sauerman in the foreground. The veteran harness maker was part of Bloomingdale after the close of the Civil War, locating here from Germany in the summer of 1865. Sauerman had a reputation for honest dealing that extended far beyond the limits of the township. After Sauerman, the harness shop was run by T. H. Reuss, who also rented sleeping rooms to Lake Street travelers.

In 1878, J. H. Roehler, Henry Holstein, and Jacob Bender were instrumental in the founding of the German United Evangelical Lutheran St. Paul Church of Bloomingdale. The congregation purchased the Congregational church on First Street, redecorated the interior, installed a new roof, and purchased a small cemetery all within the first year of its existence. Over the years, as affiliations changed, so did the church's name, always keeping the "St. Paul" in the name. There was also a gradual change from all German to English services.

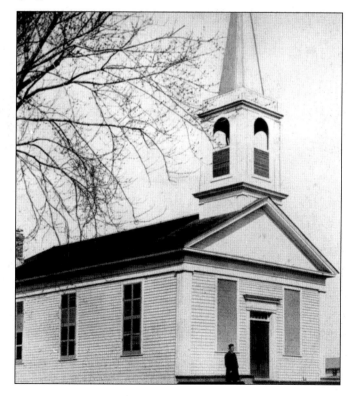

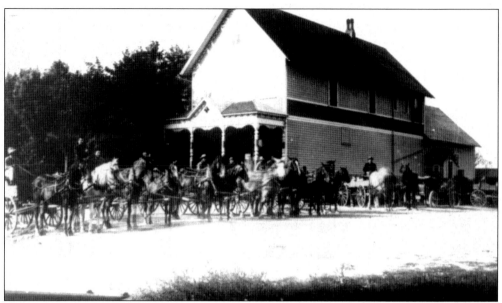

German-born Charles A. Tedrahn came to the United States at the age of 17. Following his marriage to Emma Niemier, they moved to Cloverdale, at Army Trail Road and Gary Avenue, in 1889, opening the only general store there. Located next to the railroad, Tedrahn's remained a viable business for three generations. Being a dairy farm area, the farmers lined up every morning with cans of milk on the back of their wagons waiting for the train to take the milk from their farms.

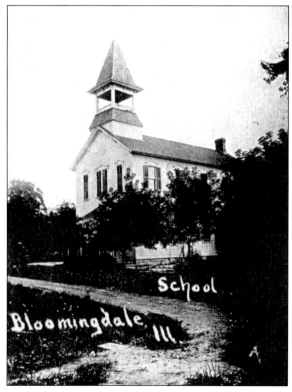

Bloomingdale School was erected in 1894 at the southeast corner of Lake and Third Streets. Straw insulation was used in the walls. The first four grades were on the first floor; the upper four grades met upstairs. During July 1899, the School District 7 board of directors hired two teachers for the 1899–1900 school year. Mayme Schmidt was hired for nine months at $35 per month to teach primary school, and Mr. E. O. Grange was engaged for nine months to teach the upper grades at $60 per month. From 1898 through 1901, Carl Iden (same last name as Bloomingdale's mayor at the time of this publication) worked as the janitor for the school for $5 a month.

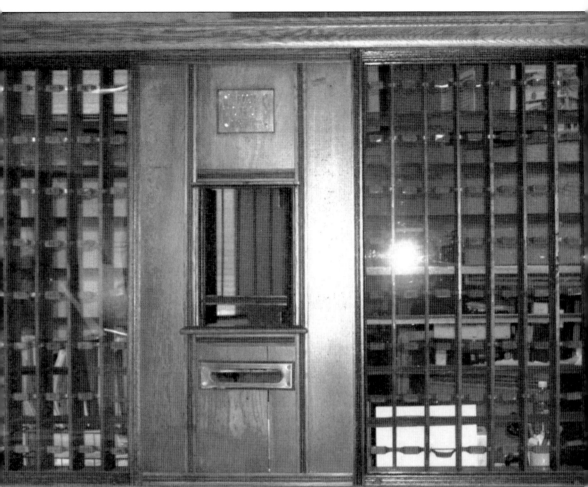

The post office has always been a gathering place for residents—somewhere to run into neighbors and catch up on the news. The moveable postal unit shown here, which was patented on June 15, 1886, was used from the 1890s until 1960 in Bloomingdale. During that time, it moved from Hjelte Drug Store on Lake Street to Kobusch Grocery at Lake Street and Bloomingdale Road to Bender's Hardware on Bloomingdale Road. The unit is currently on permanent display in the Bloomingdale Public Library local history room. The postmasters and postmistresses who served Bloomingdale from 1841 through 1983 are Anson Buck, Walter Northrup, Nubrial Hills, Sherman P. Sedgewick, Hiram Cody, George F. Diebert, John H. Roehler, Hilamon S. Hills, J. R. Dunning, John H. Kobusch, Frederick W. Kobusch, Chris F. Haseman, Minnie Satek, Aleen B. Hjelte, George M. Bender, Laura Coppock, Ethel Williamson, James Daily, and James Sutter.

On January 30, 1889, Bloomingdale sent a petition to DuPage County to allow an election for the purpose of officially incorporating the village of Bloomingdale. In the tailor shop of Francis Xavier Neltnor on Lake Street, the people of the area voted 47 to 12 in favor of the incorporation of Bloomingdale. The first village board included president Dr. Henry Vanderhoof, village clerk John H. Rohler, and trustees John Bagge, William Wangelien, Joseph Fiedle, William Rathje, and Frank Holstein. Neltnor himself did not live long enough to see this happy day. John C. Neltnor, son of Francis, had moved to West Chicago to become a very prominent citizen and successful businessman. For a number of years, he graciously hosted an annual picnic for the settlers of Bloomingdale. Pictured is John, along with an invitation to the fifth annual old settlers picnic.

The Fifth Annual Picnic

Of the Old and Present

Residents of Bloomingdale and Vicinity

Will be held at Grove Place, the residence of J. C. Neltnor,
West Chicago, formerly Turner, Illinois,

Saturday, August 7th, 1897.

Yourself and Family are Cordially Invited to Attend, and it will be esteemed a favor if you will notify any of the Bloomingdale friends whom the committee may not be able to reach.

Very Respectfully,

H. D. BARNES, Sec. JOHN C. NELTNOR, Pres

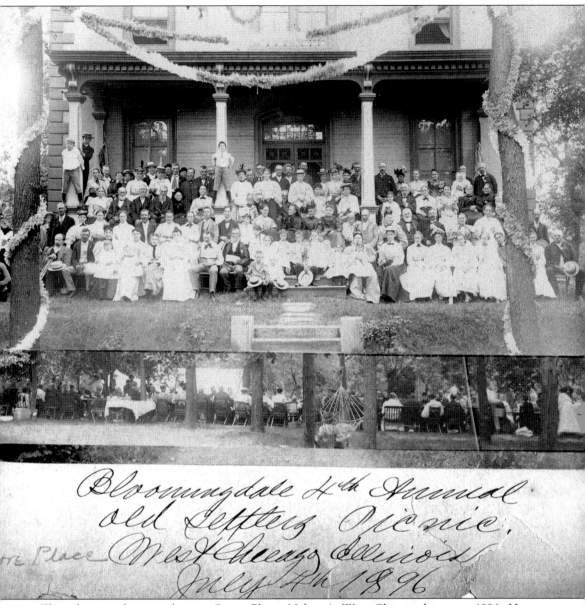

Bloomingdale 4th Annual old Settlers Picnic. West Chicago Illinois July 4th 1896

This photograph was taken at Grove Place, Neltnor's West Chicago home in 1896. Here Bloomingdale residents and others join together at the annual old settlers picnic, the fourth such reunion to take place, thanks to Neltnor's hospitality.

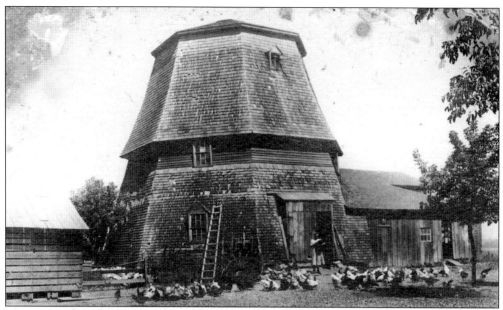

The Holstein mill along Bloomingdale Road just south of Schick continued to function until 1899 when a tornado leveled the farm and took off the top of the structure of hand hewn logs, planks, and wooden pegs. The house and barns were rebuilt on the same foundations, but what remained of the mill was only used to store grain. Eventually all that remained of the structure were the remnants of the shed to the right of the windmill. The property was sold to the Steinbecks in 1905, who farmed it for the next 50 years.

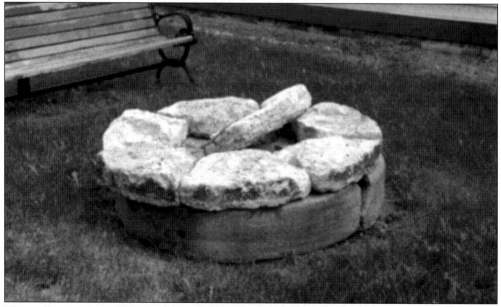

The millstone survived these many years and was lying partially imbedded on the ground on the former site of windmill. The stone was moved in an effort to save it. However, as it was so heavy, the stone was broken into pieces in transit. The pieces were moved to the north yard of the Bloomingdale Park District Museum at 108 South Bloomingdale Road and are arranged in the circular shape.

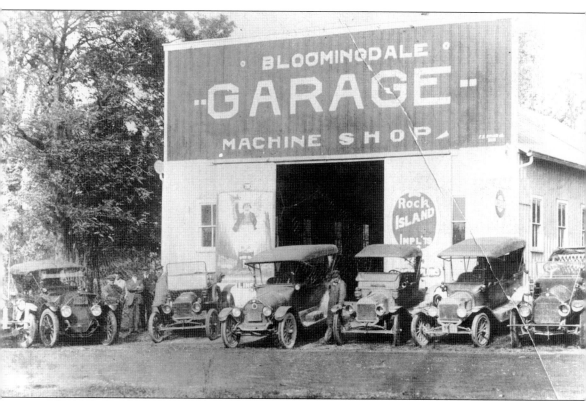

The Bloomingdale Garage Machine Shop was located on the north side of Lake Street just west of Bloomingdale Road. In additions to doing repairs, they also sold used automobiles from this site. Although this photograph is from the early 1900s, a garage/repair type of business occupied this parcel for most of the 20th century.

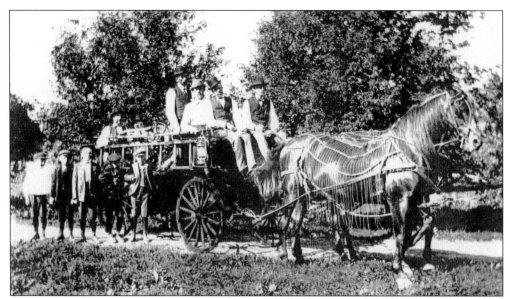

The 1906 volunteer fire department, with horse and wagon, stop along the way to a formal occasion, probably a parade. In later years, the horses named Tommy and Lady belonged to Edwin Steinbeck, whose farm was at Schick and Bloomingdale Roads. Given the time period, Steinbeck could have been one of the youngsters near the back of the wagon in this photograph. (Courtesy of the Bloomingdale Fire Department.)

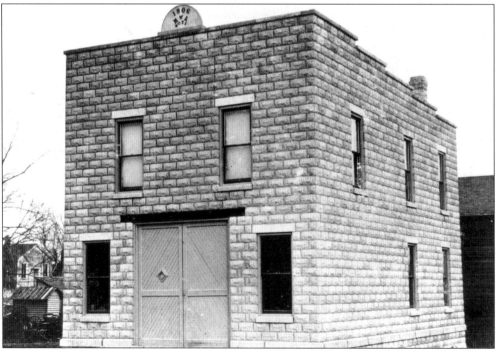

The Modern Woodmen of America Lodge 4071 was built in 1906 at Bloomingdale Road and Washington Street. It was built with cement blocks that came from Christian Hoff who made them on his property at Lake Street and Rosedale Road. The meeting hall for the Woodmen was on the second floor, but the first floor housed the fire wagon and was called the old fire barn.

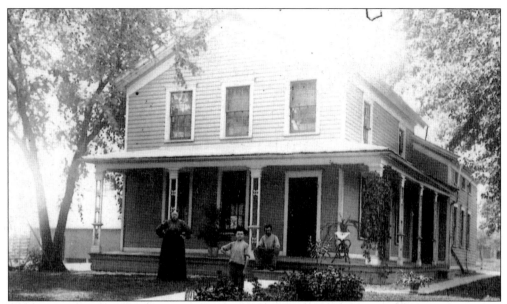

Young Edwin Steinbeck plays in the front yard of the home of his parents, Henry and Dorothy Steinbeck, located at the southwest corner of Bloomingdale and Schick Roads. The Steinbecks's dairy farm was not large, but it was very picturesque. They had many plum trees on the acreage. This photograph was taken around 1910 when the population of Bloomingdale was 462. The younger Steinbeck became a farmer but was very involved with the volunteer fire department for many years. He was elected chief for the volunteer fire department in 1929, a position held until 1966.

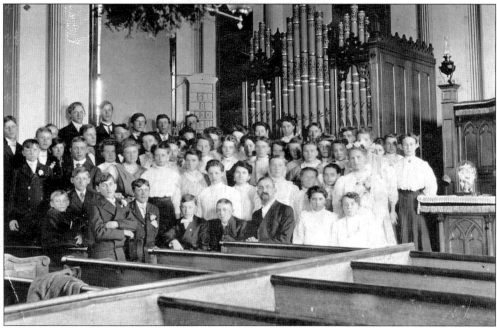

The photograph here shows a reunion of Evangelical St. Paul Church Confirmation on Palm Sunday in 1908, which was held in the original church on First Street. The altar and organ in this photograph were moved to the new church that was built in 1914. (Courtesy of Lois Franzen.)

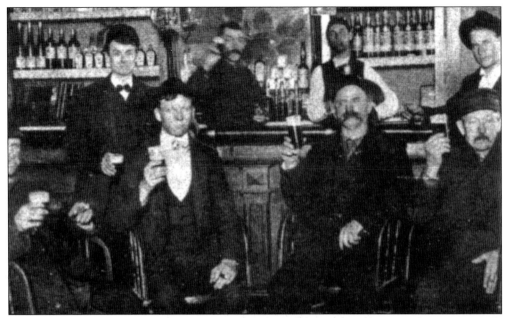

John Gardener's tavern was located at 104 East Lake Street around 1910. There was nearly always a tavern or eating establishment at the northeast corner of Lake Street and Bloomingdale Road. Seated from left to right are unidentified, ? Ackerman, James Franklin Goodwin, and Joe Miller. Standing are Charlie Stegman (left) and Edward Goodwin. Neither of the bartenders is identified, although one of them is likely to be Gardener.

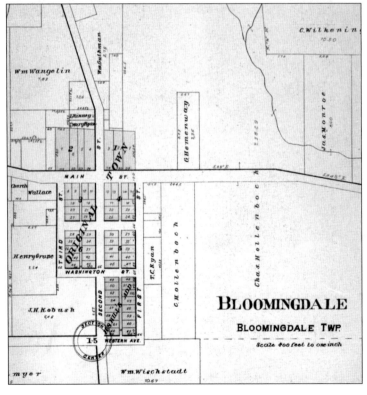

This plat from 1904 clearly shows the original town as it was laid out as well as some of the large land holdings and farms.

Three

A Close-Knit Community
1911–1940

Two Bloomingdale farming families were joined in marriage as Emma Harmening married Frank Speckman in June 1916. The Harmening farm was located along South Circle Street near Broker Road. The Speckman farm was the next farm east along Lake Street. Standing behind the bride and groom are, from left to right, Speckman's sister Luna; Harmening's cousins Clarence Leisberg and Arthur Witt; and Harmening's sister Sophie Harmening Brackman. (Courtesy of the Franzen family.)

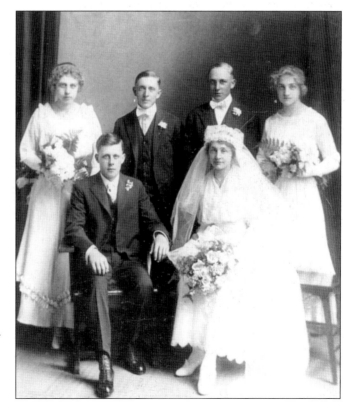

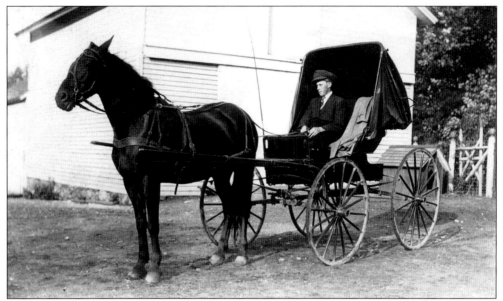

Frank Speckman received this horse and buggy as a gift for his 21st birthday. The horse's name was Lucy, and it served the young man long and well. When the horse died, a horsehair blanket and big horsehide mittens were made from her hide. Speckman's daughter Lois Speckman Franzen had childhood memories of riding in the wagon in winter with the horsehair blanket over her. She recalled it had a felt backing and was a beautiful horsehide. The blanket and mittens are now in possession of Speckman's grandson Charles Franzen. (Courtesy of the Franzen family.)

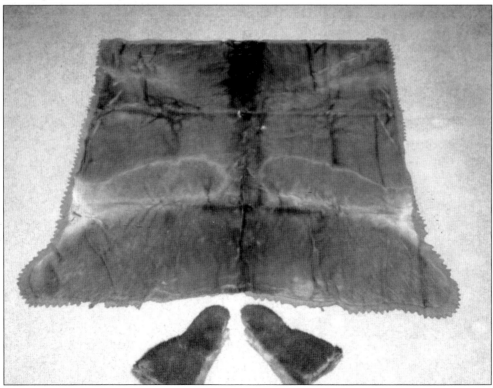

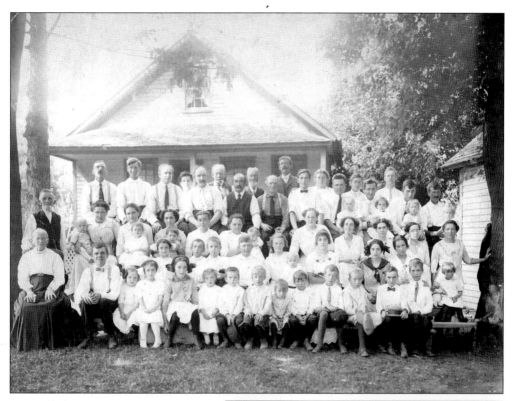

This Krumwiede family picnic took place at the home of Herman Krumwiede in 1913. The house, located at 151 North Bloomingdale Road, is reputed to be a pre-Civil War structure and was the family home for many years until it was sold in 1917 to Matthew Satek. So many people attended this family gathering that there had to be more than one seating for lunch. In the photograph of everyone sitting in front of the home, there are Krumwiedes, Wangliens, Bremmers, Frederichses, and Pictons. The patriarch of the family, Guard Krumwiede, sits in the center of the photograph. He has white hair and suspenders. In the photograph of family members sitting at the table, the sidewalks along Bloomingdale Road can be seen on the right just beyond the trees. Also visible in the background are the wagons and buggies used by relatives to attend the summer tradition. (Courtesy of the Sturm family.)

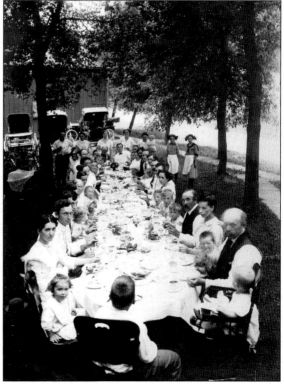

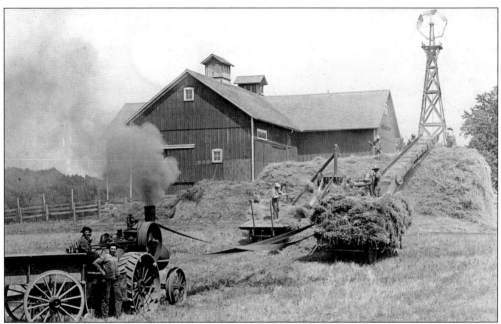

The photograph above, from about 1914, shows the Speckman farm, which was located on Lake Street at approximately Euclid Avenue. Hired hands are busy threshing hay while Louis Broker, a neighboring farmer, runs the steam engine to operate the threshing machine. Standing next to the engine is Frank Speckman, young owner of the farm. This photograph was taken looking east; the farmhouse is on the other side. The photograph at left, which is a view from the south, was taken later after the silo was erected. What looks like a dirt driveway toward the foreground is actually Lake Street. (Courtesy of the Franzen family.)

In 1913, a successful canvass was conducted for the financing of a new church building for the Evangelical St. Paul Church. In July of that year, a resolution was passed at a semiannual meeting authorizing the erection of the new church. The cornerstone was laid on May 17, 1914, almost exactly 36 years after the founding of the congregation. The new building was dedicated on November 29, 1914. Note the horse and buggy slots to the left of the church and the hitching posts and chain along First Street.

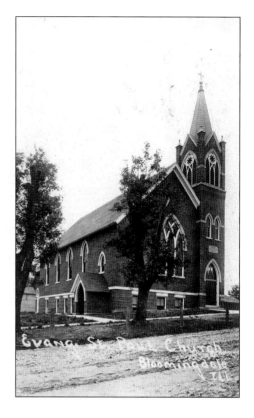

State of Illinois *village* of *Bloomingdale* ss.

To *Edward Goodwin* of the *village* of *Bloomingdale*

in the County of *Du Page* and State of Illinois:

You are hereby notified that at the Annual Election, held in said *village* at *the Town Hall* on the *17th* day of *April* A. D. 19*17*, you were duly elected to the office of *village President*

Given under my hand at *Bloomingdale* this *24th* day of *April* A. D. 19*17*.

John H. Ruecker. Clerk.

The law requires that within five days after the election is declared, or the appointment made, the city or village clerk shall notify the persons of their election or appointment.

A special meeting was called on April 23, 1917, for the purpose of canvassing the votes from the municipal election. H. A. Sumner, Edward Goodwin, William C. Fose, and F. W. Kobusch ran for mayor. The last two candidates received one vote each, while the two first names each received 22 votes. It was moved and seconded that whoever received the most votes would win the position. Since there was a tie of 22 to 22, the two candidates agreed to draw lots. Goodwin was declared the winner and went on to serve for one year as village president.

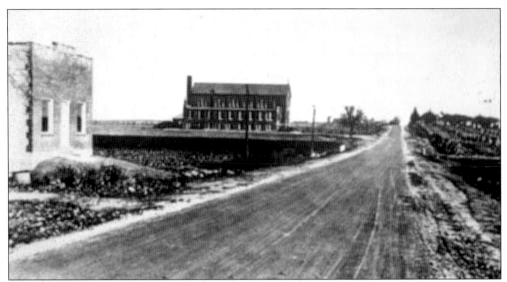

St. Isidore Catholic Church was established in March 1920 under the patronage of St. Isidore the Farmer. The original building, as seen in the distance looking east on Army Trail Road, housed the church, a rectory above the sacristy, a two-room school, and one room for the three nuns, two teachers, and one cook. In 1978, the church that is located at the northeast corner of Army Trail Road and Gary Avenue was annexed into the village of Bloomingdale. At that time there were 450 families registered in the parish. By 1980, there were 1,600 families registered. (Courtesy of St. Isidore Church.)

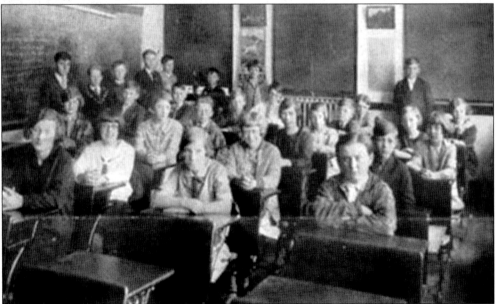

This is a classroom of St. Isidore school students in 1928. The school was in Cloverdale, but Catholic farmers sent their youngsters from Roselle, Keeneyville, and Bloomingdale also. Former students recall the bell was rung at 8:15 a.m. and the children walked into school in "a very straight line." The two nuns taught four grades each. The former students also recollected after lunch there was play time, but the boys and girls were never allowed to play together. (Courtesy of St. Isidore Church.)

44

Christian and Jennie Hoff were in the business of making cement blocks in the basement of their home located on the northeast corner of Lake Street and Rosedale Road. They had nine children, many of whom helped. The Hoff family sold many of their cement blocks to neighbors. Numerous foundations in the community are made from them. The building in the photograph, the Hoff home, was built with the cement blocks. The home was converted into a tavern called Pirate's Cove in the late 1970s. It remained as such until about 2005 when it was demolished and Old Town Bank was built on the site. (Courtesy of Margaret Hoff.)

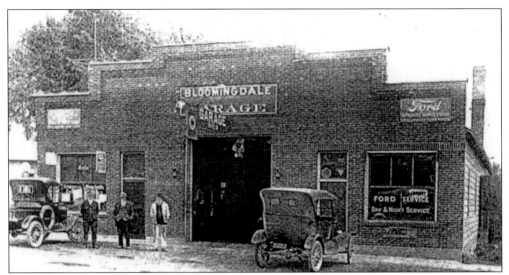

In the early 1920s, Fred Rentner and William Kroeger were the owners and proprietors of Bloomingdale Garage at 104 West Lake Street (above). This building later became the first Economart and then Pickle Piano. This is where the volunteer fire department stored their engine from 1926 through 1938. Rentner and Kroeger also had a gas station at the southwest corner of Lake Street and Bloomingdale Road, just east of the garage pictured above. Standing in front of the gas station (below), from left to right, are owner Rentner, Charles Leiseberg, John Ryan, and Henry Grupe.

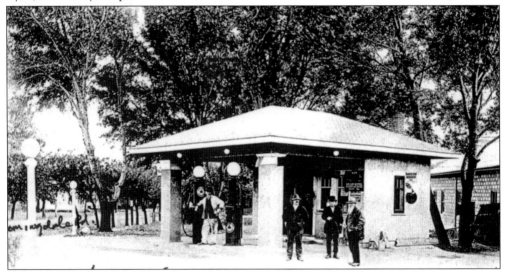

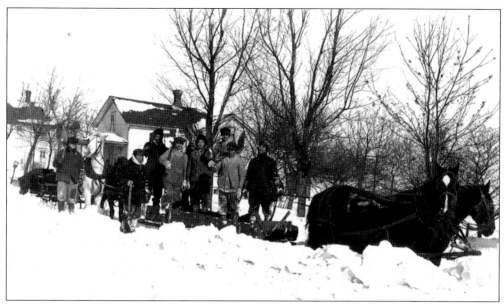

In the early 1900s when there was a heavy snow, the townspeople would come together to clear the snow enough to allow for the horses and wagons to get through. This appears to be Second Street (Bloomingdale Road) and it looks as though the men have their work cut out for them.

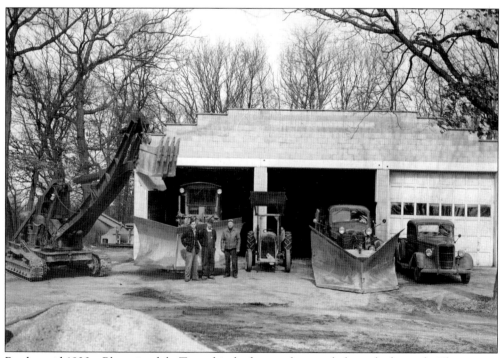

By the mid-1920s, Bloomingdale Township had snowplows to help with this task. This garage was located on Rosedale Road north of the Hoff cement block home. Pictured from left to right are Lloyd Coppock, Walter Petersohn, and the township's road commissioner John Coppock. Petersohn was the Bloomingdale Township clerk and the younger Coppock worked with his father at this time.

The 156-acre Glendale Golf Club, located east of Glen Ellyn Road on Lake Street, opened in 1921. The clubhouse pictured above had a very rustic look complete with a large fireplace that was behind the photographer from this vantage point. As time went on, additions were made to the banquet areas, but none of the additions had the ambience of this room with its bank of windows on the east side overlooking the golf course. Below is a sample of the scorecard. Note the modern "linkmobiles," available for the golfers traversing the course.

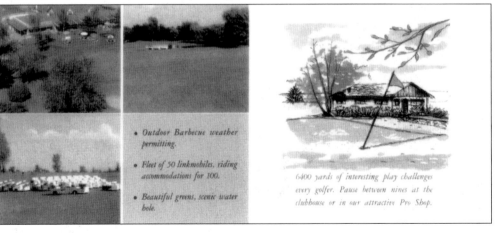

- Outdoor Barbecue weather permitting.

- Fleet of 50 linkmobiles, riding accommodations for 100.

- Beautiful greens, scenic water hole.

6400 yards of interesting play challenges every golfer. Pause between nines at the clubhouse or in our attractive Pro Shop.

The Bloomingdale School eighth grade class of 1922 put on a program titled *What Happened at Brent's* for the student body and families before they moved on to high school. As the graduating class was not large, the students recruited a couple of seventh graders to fill in the cast. Note that one of the eighth graders, Esther Bender, is a future sister-in-law of one of the little girls in the picture below.

PROGRAM

GIVEN BY

The Eighth Grade—Bloomingdale Grammar School
May 3d and 4th, 1922

"What Happened at Brent's"

TIME—Hallowe'en.
PLACE—Living room in the Brent home.

CAST OF CHARACTERS

NED, Court Jester	Arthur Meyer
ELLEN, Custodian of the Royal Seal	Marguerite Witte
REX, his Majesty	Christopher Hoff
JOE, Royal Guard	Oscar Merkens
ANNE, Royal Scribe	Louise Harmening
	Seventh Grade
BESS, Keeper of the Royal Jewels	Esther Bender
ARCH, Guardian of the Royal Exchequer	Arnold Haberkang
MRS. BRENT, Head of the Commissary Department	Anna Ohl
	Seventh Grade
THE LITTLE PRINCESS	Lillian Satek
Selections	Bloomingdale Jouvenile Orchestra

ACT I

Synopsis—A Hallowe'en revel—the excitement of a runaway—the thrill of a hidden treasure—and then —the Princess!

Vocal Solo—"Whispering Hope".... Oscar Merkens

ACT II

Synopsis—The story of the Princess—her minature court—the finding of the treasure—and then— Reta Rose!

Bloomingdale School Loyalty Song....Eighth Grade

THANK YOU!

Classmates and lifelong friends, Ethel Kroeger Bender, Mabel Ehlers Heine, and Lois Speckman Franzen are pictured on the north side of the Bloomingdale School in 1922. All three girls married and raised their families in Bloomingdale. In the background is Bloomingdale Garage Machine Shop on the north side of Lake Street. (Courtesy of the Franzen family.)

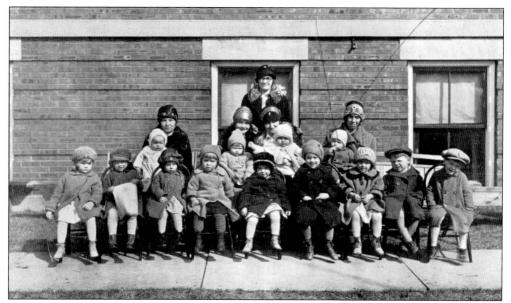

Rev. Ewald Plassman became pastor of the German Evangelical St. Paul Church in 1923. During that same year, the church instituted the Cradle Roll, a branch of Sunday school. Amanda Kroeger served in the capacity of cradle roll superintendent for the next 20 years. Plassman also began a children's sermon, which was eagerly anticipated by the younger members of the congregation each Sunday.

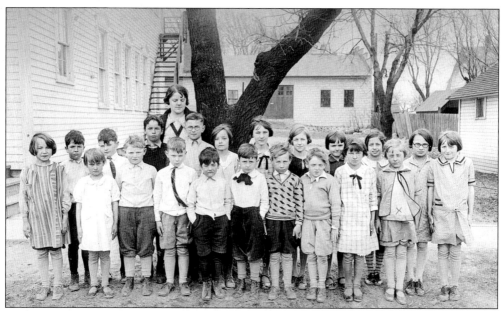

Ruth Logan taught for several years for School District 13. She is shown here with her students from the lower grades at the old schoolhouse in 1927. Logan was paid $130 a month at this time for her services.

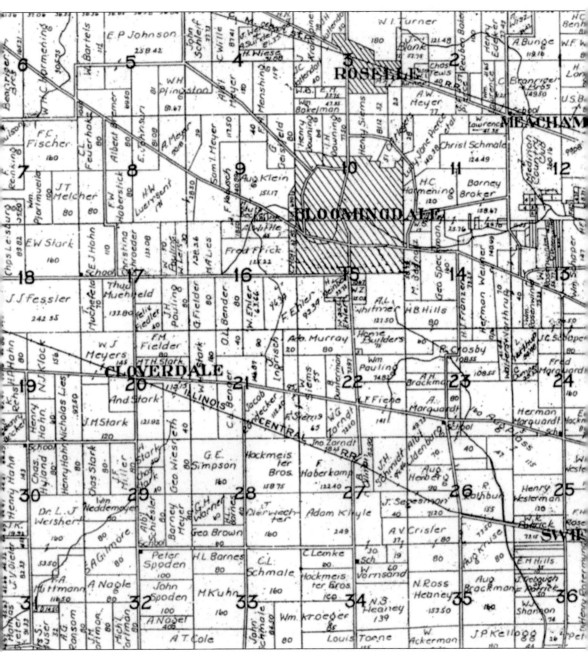

This is the plat from 1925. A great deal happened in Bloomingdale in the first five years of this decade. In 1922, Lake Street was paved and Bloomingdale and Roselle dissolved corporation. Bloomingdale was reincorporated on May 14, 1923, by a vote of 81 to 15 and Roselle stood on its own as a town. Electricity came to Bloomingdale in 1924. The whole northwest corner of Lake Street and Bloomingdale Road was wiped out by fire December 4, 1925. Meacham is listed as a town on the plat, but during 1926, George W. Meacham's namesake changed its name to Medinah for the country club founded by the Shriners.

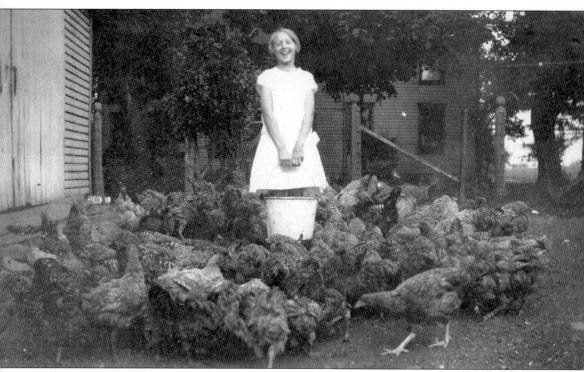

One of the chores Lois Speckman had to complete as a farmer's daughter was to feed the chickens. Judging from this photograph, she did not seem to mind it. (Courtesy of the Franzen family.)

This house is still located at 135 South Bloomingdale Road. It was built in 1926 as a Starlight model home from the Sears catalog.

The Picton house was located on Lake Street next to the site where Rooster's Restaurant is located. Joe Picton, standing in front, was born here. His niece June Pape Sturm also was born here. The Picton farm was a small farm, and it used to be west of Bloomingdale along Mensching Road. The farmhouse was still standing in the late 1990s. (Courtesy of the Sturm family.)

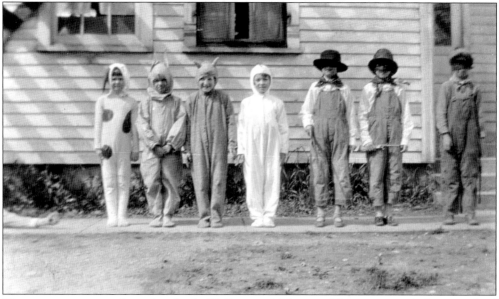

These youngsters were dressed up for the Halloween celebration. The picture was taken outside of Bloomingdale School on Lake Street in 1930. The children, from left to right, are Dorothy (Dot) Iodor, Dorothy Jane Reynolds, Margaret Rathe, Mae Klein, Margaret Stegman, unidentified, and Donnie Goodwin. (Courtesy of the Goodwin family.)

John A. Ioder was elected village president from 1929 through 1933. He was also the father of Dot, the little girl in the spotted dog costume in the picture above. (Courtesy of the Goodwin family.)

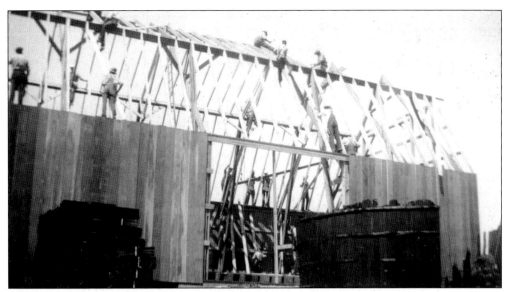

The farmers in the Bloomingdale area always helped each other out. Whether it was threshing, bailing hay, or filling the silos, they were there for each other. So when a fire totally destroyed the Speckman barn in 1933, killing six horses, a sow, and a bull, Speckman's friends, neighbors, and fellow farmers were on hand to help raise a new barn. Some 100 local people were served lunch and 75 were served dinner that day as they worked to get the barn rebuilt. (Courtesy of the Franzen family.)

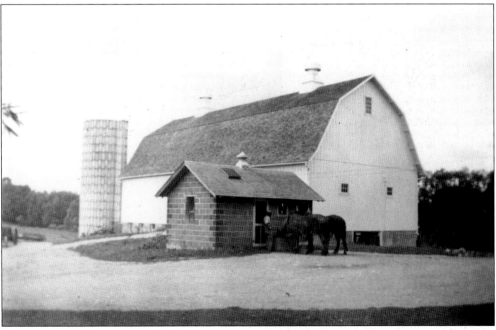

The new Speckman barn is shown in this photograph. In the foreground is the milk house where the cans of milk were kept cool until they were picked up each day. (Courtesy of the Franzen family.)

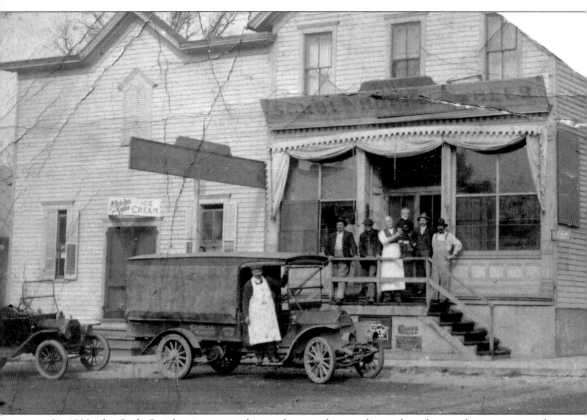

In 1933, the Seth Smith grocery market and general store, located at the southeast corner of Bloomingdale Road and Lake Street, caught fire in the early morning. Smith and his family were asleep in the back part of the store and did not discover the blaze until it was well underway. They did manage to get an old player piano out of the store and move it to the tavern across the street. The building was of wooden construction, with a one story frame annex to the east and was said to have been close to 100 years old. Many years previous to Smith owning it, the structure was raised and a basement constructed. The local Masonic lodge and Eastern Star chapter occupied the hall on the second floor, and their records and belongings all went up in smoke with the rest of the building. The old cobblestone basement walls remained. The Bloomingdale and Roselle fire departments answered the alarm and succeeded in saving some of the furnishings and stock in the building, as well as preventing the flames from spreading to other nearby buildings. Nevertheless, the structure had to be rebuilt.

A school bus transported Bloomingdale and area teens to Glenbard High School in Glen Ellyn. This photograph was taken around 1934. Lois Speckman Franzen remembered it was a ramshackle bus that had "more mechanical problems than you could shake a stick at." Ruth Hillman, who was a few years older than Franzen, recalled, "When the snow got too high, you had to get out of the bus to push it." Franzen was the first passenger to be picked up as the route began in Bloomingdale. The morning trip took them to Schaumburg to pick up one girl, then to Roselle to pick up several students, back through Bloomingdale for a couple more, out to Cloverdale for a few more and east on Army Trail Road to Glen Ellyn Road for a few more, then on to school. It is hard to imagine that many teens fit in this bus. Below is a photograph of some of the bus riders before their trip home began.

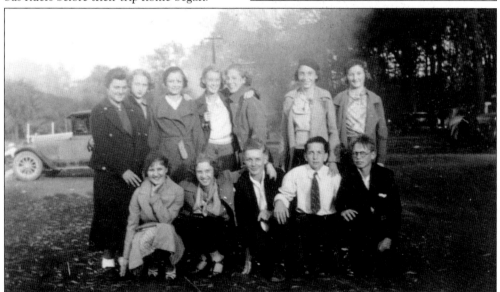

The new Bloomingdale school, Central School, opened in 1937 on Day Street, one block west of Third Street. The brick building, which cost $1,500, had two classrooms—one for the lower grades and the other for upper grades. Initial enrollment was 60 children. School District 13 began to rent the old school house on Lake Street to the village of Bloomingdale for $15 a month.

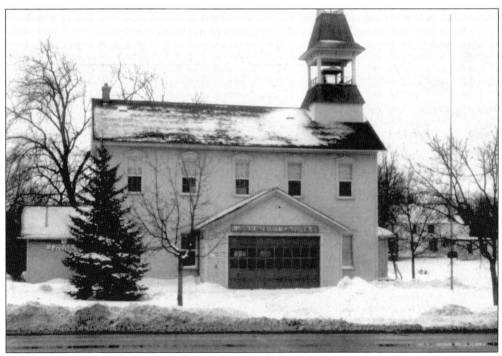

The first meeting of the Bloomingdale village board at 108 West Lake was held in August 1938. The building also became home to the fire and police departments. Notice the addition on the north side to accommodate fire trucks. School District 13 held ownership until it sold the property to the village of Bloomingdale on September 30, 1950. The village installed indoor plumbing in 1954.

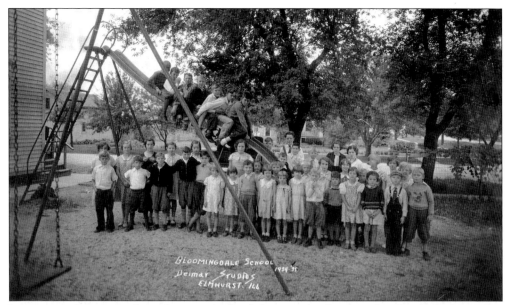

In an unusual departure from the typical school photograph of students lined up with the teacher in back, this photograph is more creative. The class picture for the school year of 1934–1935 was taken on the slide located on the north side of the school on Lake Street. All eight grades are represented. One of the boys on the slide is the future fire chief Harvey Koehn. Also in this picture, but not identified, are Merlyn Fessler and Herbert Frick, who were the last two students to graduate from this schoolhouse in 1935. (Courtesy of the Sturm family.)

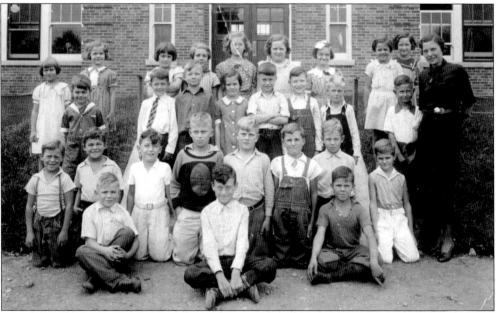

This photograph of students in 1938 was taken in front of the newly built Central School; the teacher is Ruth Patch. It appears this would be the older of the two classes—fifth through eighth grades. Patch was paid $125 a month. Elsie Garrison, the other teacher, was paid $130. It is interesting to note that more of the youngsters are smiling, as is the teacher, which was something not often seen in past school photographs.

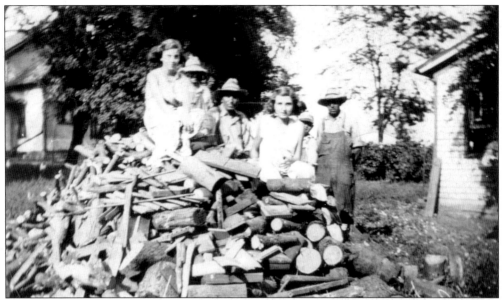

In the 1930s, farming was still a major occupation in Bloomingdale. All along Army Trail and West Schick Roads, corn and cows were a big part of the scenery. Many of these farms had been in a family for decades. Edwin Steinbeck's farm at Schick and Bloomingdale Roads has been mentioned. Going west on Schick Road, the Ehlers had a very large farm; the Bender's farm was west of that. Part of Stratford Square was built on the former Bender's farm. Herman Frick's farm was north of these and stretched all the way to Lake Street. There was a threshing ring of about 20 farmers around Bloomingdale until it broke up in 1927. Following that, Frick, Conrad Bender, and Fred Ehlers threshed together until 1937 when Ehlers sold his farm. The photograph above is of the Ehlers family; daughters Esther and Mabel are sitting on the woodpile. Their father is visible between them. The one below is of the Ehlers barn, which remained out on Schick Road until residential development took its place.

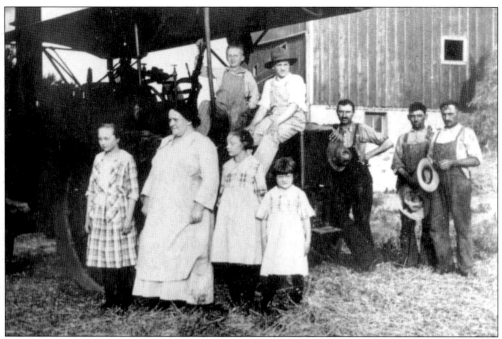

There were three Bender farms in Bloomingdale. This Bender family lived on the site of the farm on Schick Road, which was started by Michael Bender in 1858 when he purchased a 160-acre parcel. Following his death, his son Jacob took it over, followed by his son, Conrad. The man on the right in this photograph is Conrad.

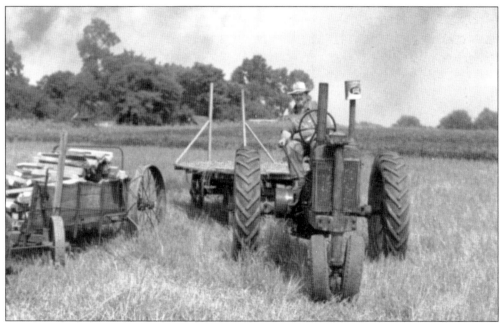

Herbert Frick continued to farm his father's farm into the 1970s. He was fond of bringing his corn husker to Septemberfest so the kids could see how it was done.

In 1937, young couples had limited options for places to go on a date in Bloomingdale. Although it was quite a trip into the city of Chicago back then, Don Goodwin and Dot Ioder (left) along with Bob Smith and Lorraine Bergstrom enjoyed the thrills and chills of Riverview, a Chicago amusement park. The year prior to this visit, Riverview converted an old observation tower, the Eye-Full Tower, into a new ride called the Pair-O-Chutes, which was a ride guaranteed to result in a clinch all the way down. (Courtesy of the Goodwin family.)

From left to right, Helen Steinbeck, Virginia Randecker, Carol Steinbeck, and June Randecker were dressed in their Sunday best when this photograph was taken on the steps of Martin Neiman's home on Second Street (Bloomingdale Road) next to the Randecker house. (Courtesy of June Stark.)

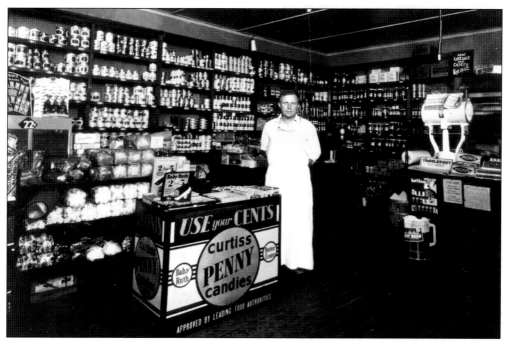

William Rathe stands ready to serve his customers in his grocery store located on Lake Street in the 1930s. Rathe, like many of the local businessmen, was a volunteer fireman in Bloomingdale.

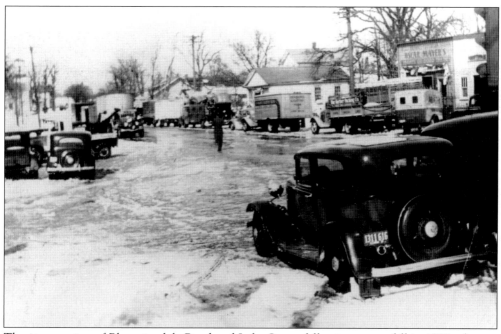

The intersection of Bloomingdale Road and Lake Street following a snowfall in 1930 takes on the look of rush hour traffic with trucks lined up on the side of the street. This appears to be taken from the east looking west. In the upper right-hand corner is a grocery store. Note the Oscar Mayer's sign at the top of the building.

This 1938 bill from Randecker's Hardware shows William Randecker's signature next to the paid notation. The items listed show the rural character of Bloomingdale during this time. They include a frame for a crib and granary and a frame for a hog house.

Aleen Hjelte and unidentified residents enjoy a sunny afternoon on the steps of Hjelte's Drugstore, fondly known as "Doc Hjelte's," by the locals. John Hjelte not only ran a combination pharmacy, newsstand, and post office, but he also served as a justice of the peace for more than 25 years and was elected mayor from 1928 to 1929 and 1945 to 1952. It was said that Doc Hjelte, who was not a doctor, used to have little pills to give to people that would cure everything; everyone swore by them.

In honor of DuPage County's centennial, a wagon train traveled along Lake Street. One of the families participating was the Petersohn family. Pictured in the waggon below are Walter Petersohn (left) and his son Leonard, with Walter's wife, Clara, standing alongside the wagon. The elder Petersohn served as a Bloomingdale trustee then village clerk from 1934 to 1960. He also served as the Bloomingdale township clerk for more than 20 years. Bloomingdale joined with Roselle to celebrate DuPage County's centennial on July 15, 1939, with a picnic. A pageant was also held in honor of the occasion.

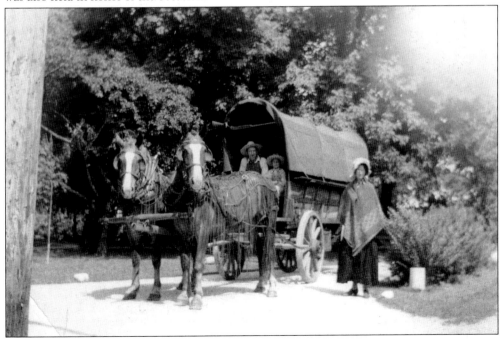

Several events took place in observance of the DuPage County centennial in 1939. Among these was the DuPage County historical pageant, which took place at Martin Park in Naperville on September 11 and 12, 1939. Twenty-seven Bloomingdale residents participated in the depiction of the creation of DuPage County in 1839. Lead characters were Herman Frick, Rev. Karl Gaertner, Walter Petersohn, and Harold Ryder. Others in the pageant were Anna Steinbeck, Louise Ruecker, Clara Petersohn, Mrs. Harold Ryder, Eleanor Frick, Mrs. Charles Edwards, Amanda Kroeger, Dorothy Thieman, Mrs. George Rentner, Mrs. Karl Gaertner, Clara Nieman, Amanda Ehlers, Edna Grupe, Fred Ehlers, Charles Edwards, William (Kelly) Kroeger, George Rentner, Arnold Raiha, Henry Grupe, Edward Banks, and William Grupe.

The Bloomingdale-Roselle-Itasca-Medinah (BRIM) bowling league was formed in the 1940s. It went on for several years. Bloomingdale had a bowling alley years earlier. It was 1901 when Bloomingdale Bowling Alley opened. It had two lanes and 17-year old Herman Haberstich was the pinsetter. Haberstich served as a village of Bloomingdale trustee from 1953 to 1955.

Four

A GOOD LIFE
1941–1960

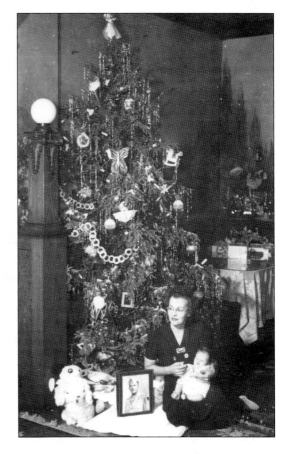

Mary Ann Kowalczyk Zidek holds one-month-old Emil Zidek II, named for his father, whose photograph is under the Christmas tree. The year was 1944 and the young mother, like so many young wives and mothers during World War II, celebrated Christmas without her husband. The elder Zidek was the chief medical officer attached to the 751st Artillery Battalion and was at the Battle of the Bulge when this photograph was taken. (Courtesy of Emil Zidek.)

Becker's Standard Service Station was located on the southwest corner of Bloomingdale and Lake Street. This receipt from the 1940s belonged to Edward Randecker, Richard Randecker's father. It appears he received 50¢ credit on his bill for a battery. (Courtesy of the Randecker family.)

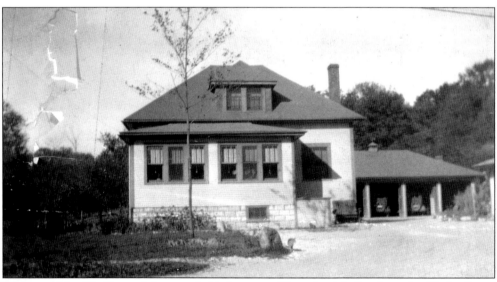

Walter and Lucille Krumwiede owned this home on Bloomingdale Road north of Lake Street near the Forest Preserve. He was an excavator by trade, but the couple also had a service station and an ice-cream and candy store. When Lucille heard a car pull in, she came out of the house to help the customer.

This group of young ladies pictured with Pastor Karl E. Gaertner makes up the 1941 confirmation class of St. Paul Evangelical and Reformed Church. Seated are Lucille Peterson (left) and Georgene Rossiter. Standing from left to right are Leone Hartmann, June Pape, Erna Huber, and Carol Steinbeck.

O. P. A. Form No. R-306	**UNITED STATES OF AMERICA**	Not Valid

Serial No. C 8325876 **OFFICE OF PRICE ADMINISTRATION** Before *April 29, 1942* Date

SUGAR PURCHASE CERTIFICATE

THIS IS TO CERTIFY THAT:

Name: *Walter Tedrahn* Address: *Cloverdale*

City: *Cloverdale* County: *Du Page* State: *Illinois*

is authorized to accept delivery of

Two hundred and thirteen (*213*) pounds of sugar pursuant to Rationing Order No. 3 (Sugar Rationing Regulations) of, and at a price not to exceed the maximum price established by, the Office of Price Administration.

Local Rationing Board No. *22–1* Date *April 29, 1942*

Du Page *Illinois* By *C. H. Colin*

County State Signature of issuing officer *Registrar* Title

This Certificate is not valid unless signed by an issuing officer authorized by the Office of Price Administration.

During World War II, sugar was one of a number of foodstuffs rationed. This sugar purchase certificate represents the amount rationed to Tedrahn's store in Cloverdale for resale. The War Ration Board operated out of the Bloomingdale Township Hall at Bloomingdale Road and Franklin Street. Walter Tedrahn was the family's second generation running the store after it was originally opened in 1889. Like other towns across the nation, Bloomingdale passed civilian defense and air raid blackout ordinances during 1942.

In the 1940s, hunting and fishing were activities a young boy could enjoy with his father. Edward Randecker and his son Richard show off the rabbits they shot in the fields close to their home at Western and Second Streets (Schick and Bloomingdale Roads). In the second photograph, the younger Randecker proudly displays his catch from fishing at Stark's creek. (Courtesy of the Randecker family.)

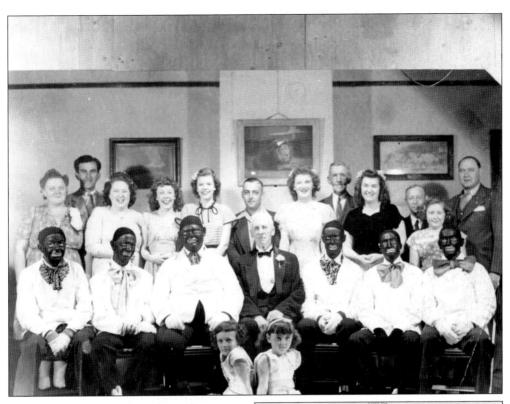

In 1946, the Bloomingdale Community Club troupe put on a show called *Black Face Minstrel and Home Talent* in two evening performances for the community. The names of many of the performers are familiar. The upstairs room in the village hall was the venue for this variety show. The club never put on any more shows, but this one was very successful. (Courtesy of Margaret Hoff.)

BLOOMINGDALE COMMUNITY CLUB
Presents

BLACK FACE MINSTREL AND HOME TALENT

AT VILLAGE HALL
THURSDAY AND FRIDAY EVENINGS,
APRIL 25 and 26, 1946
Time: 8:00 P. M.

Cast of Characters

Interlocutor	JOHN F. GROSVENOR
Piano Accompanist	MRS. RUTH BENDER
Director	JOHN E. LAMOS

ENDMEN

Mr Tambo	HERBERT FRICK
Mr. Bones	CHRIS HOFF
Mr. Scoot	EDWIN STEINBECK
Mr. Jefferson	ONIE KUNTZ
Mr. Mutt	EDWARD MORSE
Mr. Gabb	CHARLES EDWARDS

PROGRAM

1. Opening Chorus	Entire Cast
2. Smoke Gets In Your Eyes	Miss Phyllis Picton
3. Harmonica Duet	Mr. John Hjelte
	Mr. August Van Goethen
4. Wishing	Miss June Pape
5. Piano Accordion	Mr. Earl Zarndt
6. Tap Dance and Acrobatics	Anna Kuntz
	Alice Van Goethen
7. The Bells of St. Mary's	Miss Erna Huber
8. Piano Solo	Miss Janet Thiemann
9. Sunshine of Your Smile	Miss Carol Steinbeck
10. Heinberg Duo	Marjorie Heinberg
	Mr. Albert Heinberg
11. Piano Duet	Mrs. Ruth Bender
	Mr. Earl Zarndt
12 Closing Chorus	Entire Cast

Program Compliments of
Edward Morse and George Becker's Service Stations

In spite of conditions, we have endeavored to meet your requirements. As raw materials are released and restrictions are lifted, we will avail ourselves of adequate stocks to serve your need.

ERWIN H. FRANZEN

LUMBER • COAL and BUILDING MATERIAL
MILL FEED, GRAIN, SEEDS, ETC.

Tel. Wheaton 477-Y-2

CLOVERDALE ★ ILLINOIS

JANUARY 1947						
SUN	MON	TUE	WED	THU	FRI	SAT
.	1	2	3	4
5	6	7	8	9	10	11
12	13	14	15	16	17	18
19	20	21	22	23	24	25
26	27	28	29	30	31	. .

HELP WANTED

This 1947 post-war calendar distributed by Erwin Franzen's establishment in Cloverdale makes a reference to war shortages. It took a while before all these materials became more readily available. Three years after this calendar appeared, the Cloverdale Post Office closed after 62 years. In 1979, Cloverdale was incorporated into the village of Bloomingdale. Reminders of Cloverdale can be seen along north Army Trail Road on the white and green buildings across from the Wal-Mart center. The Cloverdale sign from Tedrahn's faces Army Trail Road as does the Cloverdale Dairy sign from Martin Stark's farm, which was located on the south side of Army Trail Road.

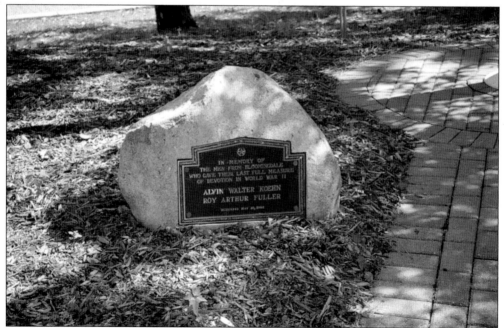

Bloomingdale sent some 68 sons and husbands into U.S. military service during World War II. Two of them, Alvin Walter Koehn and Roy Arthur Fuller, were casualties. A memorial stone sits near the gazebo at Bloomingdale Road and Fairfield Way, recognizing their sacrifice.

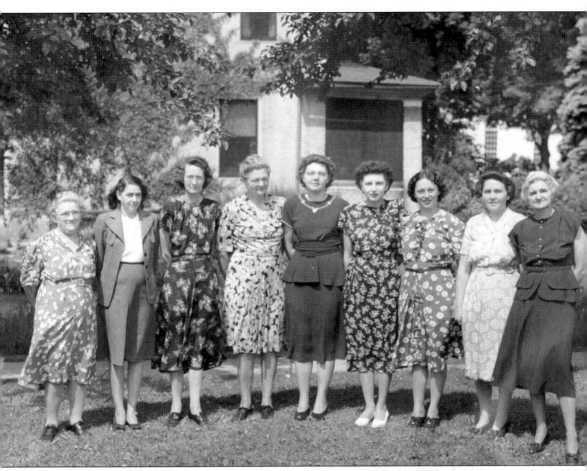

The Bloomingdale Volunteer Firemen's Auxiliary was organized in 1945 in order to assist the firemen on picnics, social events, and financial aid toward the purchase of fire equipment. The membership was limited to the wives or mothers of the firemen. In November 1947, the auxiliary presented the fire department with an E and J resuscitator, the latest and most modern equipment for respiratory aid available at that time. Pictured from left to right are Bertha Haberstitch, Edna Watson, Clara Petersohn, Matilda Koehn, Esther Raiha, Mabel Heine, Eleanor Van Goethen, Margaret Hoff, and Anna Steinbeck. Member Marie Rathe was not pictured. (Courtesy of the Bloomingdale Fire Protection District.)

Irene Kowalczyk relaxes on a tree swing with her nephew at her father's farm on Lake Street. This photograph represents the kind of laid-back feeling that Bloomingdale had for at least the first half of the 20th century. Residents of Bloomingdale called Kowalczyk's father "Joe the baker" because he was a baker in Chicago who commuted every day and because Kowalczyk was a name so unlike the many German monikers they were used to. (Courtesy of Emil Zidek.)

Four-year-old Emil Zidek used to walk west with his mother along Lake Street from his grandfather's farm to John "Doc" Hjelte's pharmacy. In this photograph, Zidek is facing west and Lake Street is visible on the right side. On the other side of Lake Street where there is all farmland, Springbrook Shopping Center and the Suncrest residential development eventually filled the landscape. (Courtesy of Emil Zidek.)

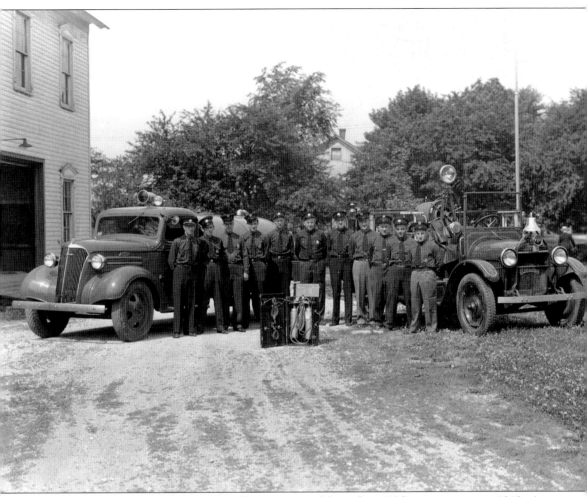

The Bloomingdale Volunteer Fire Department celebrated its 25th anniversary in 1948. At that time, they were housed in the village hall located in the old school building on Lake and Third Streets. On the left-hand side of the photograph, the open garage door on the village hall is visible. The volunteers posed in front of their two engines. They are, from left to right, Edwin Steinbeck, Karl Lorenz, Russell Watson, Alfred Koehn, Christopher Hoff, Arnold Raiha, Walter Petersohn, Elmer Heine, Robert Haberstitch, Gus Van Goethen, and Willis Rathe. The resuscitator received from the Bloomingdale Volunteer Firemen's Auxiliary the previous year is proudly displayed in the foreground. (Courtesy of the Bloomingdale Fire Protection District.)

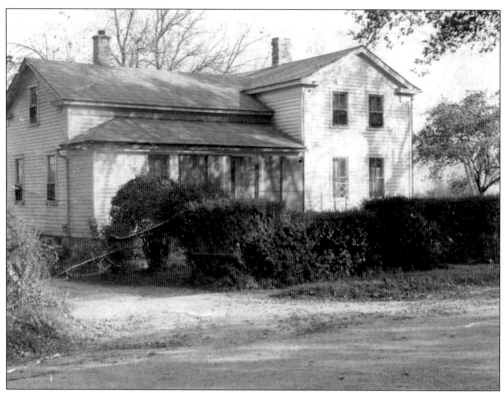

This house, built in the 1800s at the northeast corner of First Street and Schick Road, was originally owned by Mr. and Mrs. August Koehn. Lawrence "Harvey" Koehn (a future Bloomingdale fire chief) grew up there and remembers a wall separated the upstairs bedrooms. The girls slept on one side and the boys on the other. The house was actually two houses joined together by a fieldstone foundation. Interestingly, the man who worked as the fire chief after Koehn, Richard Randecker, was born in and lived in the same house before the Koehns moved back in. The outhouse that stood at the southern end of the house was still being used in 1950. The building was purchased by Charles (Chip) Goodman in the early 1980s and became Art Craft Photography Studios for more than 20 years. Goodman cut a hole in the wall between the two upstairs bedrooms to more easily access his office space from the main stairway. (Courtesy of Harvey Koehn.)

Mechanic by day, musician by night—that was Wilbert "Whip" Sturm. Sturm lived at 124 North Bloomingdale Road with his wife, June, and their children. He ran an automobile service business just across the street from the house. Sturm, who played the concertina for years, had a band known as the Melody Whips. The four-piece group performed at parties, taverns, dances, and anywhere else they had a chance to play. From left to right, the musicians are Mel Retike on drums, Harvey Larson and Dick Stallman on saxophone, and Whip Sturm on the concertina. Below is Whip's Auto Service. While both the home and the automobile repair shop still stand, only the home remains in the family. (Courtesy of the Sturm family.)

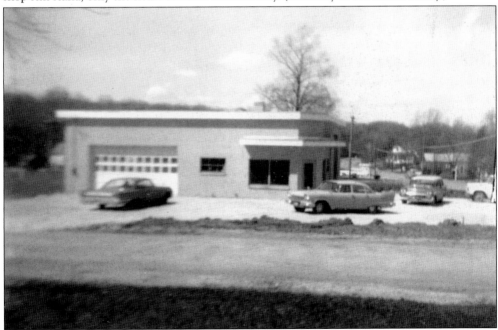

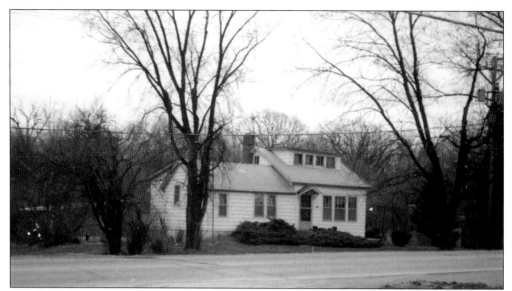

Ethel and Norman Williamson brought their family here from Chicago in 1950 in search of clean air and open space. The Williamson home was located on the east side of Bloomingdale Road across from the forest preserve. The house was over 100 years old when they purchased it; the original structure being a couple of rooms with several additions added on. Ethel said when she saw the lilacs blooming in the spring, they knew moving there was the right choice. Following the death of her husband in 1955, she finished raising the family as a single parent and remained a vital and active member of the Bloomingdale community. (Courtesy of the Williamson family.)

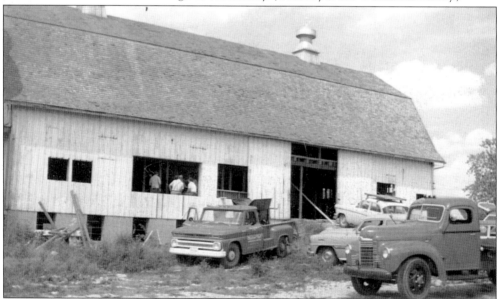

Elmer Blecke was a local farmer who had a grove located east on Lake Street close to Glen Ellyn Road that was available for gatherings and other outdoor events, such as the donkey baseball games and end-of-the-year school picnics. Blecke bought the neighboring Speckman barn on Lake Street in 1954 with plans for it to become a retail outlet, restaurant, and playhouse. In the photograph, the architects and business owners confer on the transformation from barn to playhouse.

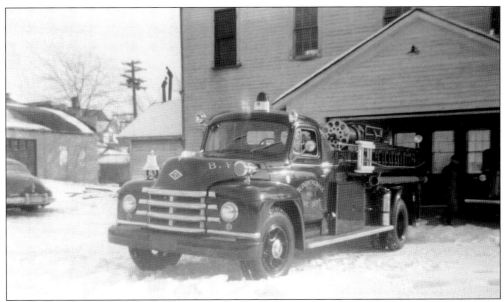

In 1950, the village officially purchased the old school building on Lake Street from School District 13 for $5,500 and it became the village hall. The fire and police departments continued to use the first floor and court was held on the second floor. In 1942, the fire department purchased a second truck equipped with a 1,000-gallon water-supply tank. An additional structure was added on to the north side of the village hall to accommodate the length of the truck. (Courtesy of Petges family.)

The police department was located toward the back of the village hall building. At that time, William Rossi was the police chief. Norman Williamson worked part time. In 1952, Bloomingdale was mentioned in *Motor Trend* magazine as the biggest speed trap in the country. Williamson noted Rossi told him that Bloomingdale did not have a ticket quota, but he wanted him to give out eight that day. One of Williamson's favorite memories was testing out the police department's 1957 Ford. It could do 110 miles per hour. Williamson attests to that; he took it out on Lake Street and got it up to 110 miles per hour in second gear. (Courtesy of Petges family.)

Bloomingdale residents Claire and Stan Haverkampf took in their first foster child, Mark Lund, a Down syndrome child with a severe heart defect. By opening their home and hearts to Lund, the Haverkampfs began what would become a commitment to provide a loving, nurturing environment to many more infants, children, and adults with developmental disabilities. More than a half-century later, Marklund Charities continues to provide unique homes and facilities where the mission is to help its residents and students to reach their highest potential and experience as full a life as possible. At left, Lund celebrates his first birthday. Below, Claire (middle) enjoys a moment with friends Caroline Corner (left), who was also a volunteer, and Gertrude Hemhauser. (Courtesy of Marklund Charities and Diane McLaughlin.)

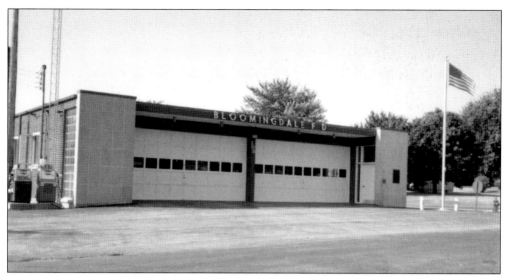

In 1954, the Bloomingdale Fire Protection District No. 1 was formed. Edwin Steinbeck became the official fire chief. In 1958, the fire department moved to its own offices at 108 West Washington Street. The following four men listed on the building committee were all longtime volunteer firemen: Chris Hoff, Louis Petges, Robert C. Smith, and Steinbeck.

As in most places in the late 1950s, blue suede shoes and jackets reminiscent of "the Fonz" were all the rage in Bloomingdale. Area teens formed car clubs; Bloomingdale's club was called the Drifters. Club members were identified by small metal plaques that hung from two little chains on the car's back bumper. Members Jac Williamson and Chuck Franzen recalled that Itasca had a club with the same name, so the young men met to "hammer it out" in a local barn. As the men recall, it just turned into a social event and the two groups merged since neither club had many members and they both attended the same high school. Drag racing was also one of their favorite pastimes, whether it occurred down the middle of Bloomingdale Road or in front of Lake Park High School when it was brand new (until the school passed a rule prohibiting the practice). The members of the Bloomingdale Drifter's club shown below, from left to right, are Franzen, Bob Smith, Dan Banks, Eugene Pavone, and Williamson. (Courtesy of the Franzen family.)

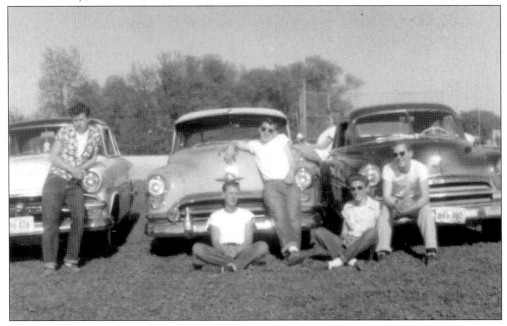

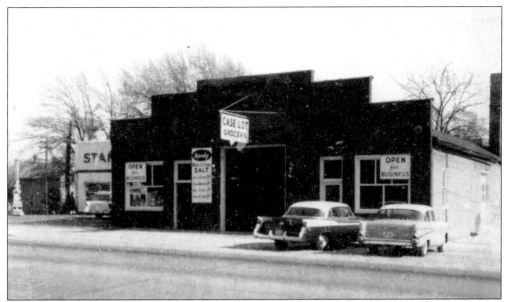

Economart was opened by Wallace and Georgene Geils in 1958 as Case Lot Grocery on Lake Street just west of Bloomingdale Road in what is now known as Pickle Piano. Essentially a forerunner of the Sam's Club and Costco stores of today, the young couple offered customers the opportunity to buy in bulk. They carried canned goods, pet food, fertilizer, pool supplies, paint, work clothes, motor oil, and so on. If something was not available at Economart, the Geilses could get it. Residents of Bloomingdale, the Geilses were active in the schools, church, local organizations, and politics. Wallace served on several village committees and a term on the village board from 1966 to 1971. In the bottom photograph, he is seen in the early years. Note that the store even developed film, as is visible to the right behind his shoulder. (Courtesy of the Geils family.)

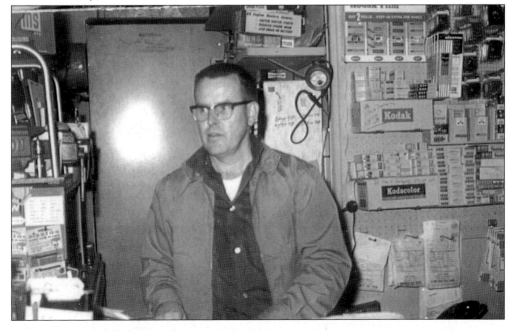

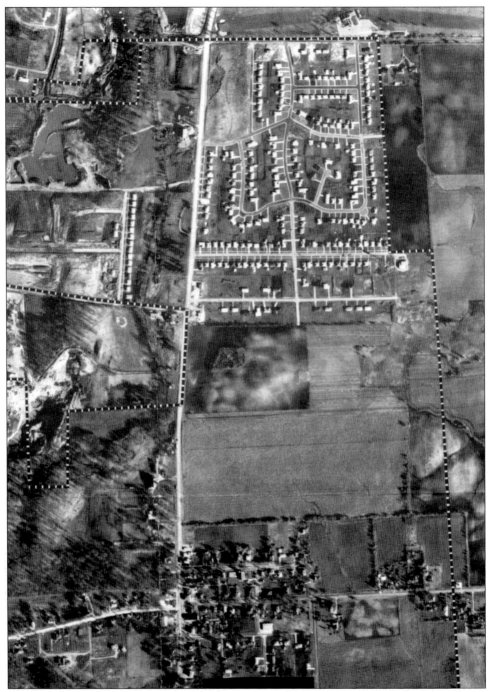

This aerial view from 1960 shows the earliest subdivisions with much open land surrounding them. The top of the photograph is east. At the upper right-hand side is the Suncrest area. The long road running through the middle is Lake Street. The one street on the left (north) of Lake Street with homes is Park Avenue. At the bottom of the photograph, Bloomingdale Road can be seen going through the original area of town, and a small area of South Lakewoods is visible. (Courtesy of Diane McLaughlin.)

Five

THE BOOM BEGINS
1961–1983

Adventureland sat on 40 acres at the northwest corner of Lake Street and Medinah Road, featuring 55 rides and attractions. With the roller coasters, including the 35-foot Small Bobs and the 60-foot Big Bobs, there were plenty of thrills. The 1960s and the years following marked the beginning of change. Just like each new turn or drop on the coaster, each annexation or sale of farmland brought uncertainty and maybe a little fear, but there was excitement in the air. Nonetheless, this time of change still brought people together and they were having fun.

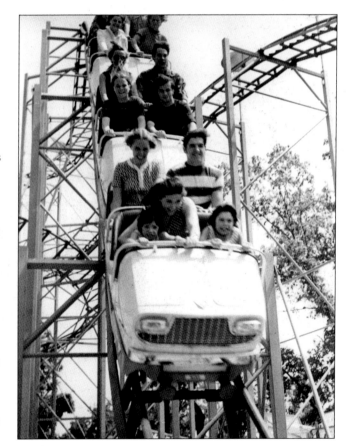

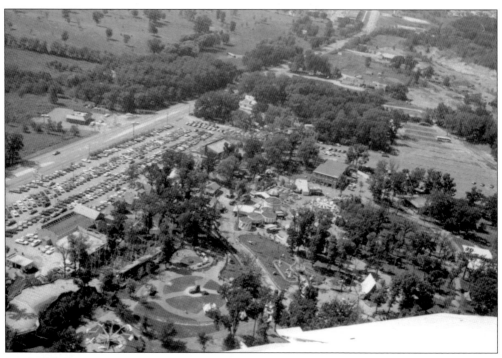

Opening in 1961, the park was set up to appeal to young adults. Rides included the Rocko Plane, Super Himalaya, Fighter Planes, Octopus, Rambler, Flying Bobs, Caterpillar, Whip, and YoYo Swings. Food, ice cream, and souvenirs added to the fun. Adventureland was open every day from Memorial Day through September, then weekends only until the end of the season. Admission was $3.75; a $3 "Starlight" rate was featured after 6:30 p.m. All rides were free. Attendance averaged 650,000 per season. Many Bloomingdale teenagers worked at the park as summer help. Dance bands such as the Crying Shames were promoted by WLS radio station and played rock and roll on weekends. The roller coasters and Ferris wheel stopped in 1977. Many rides went to Santa's Village. The village of Bloomingdale annexed the site in 1984. Today a Bridgestone-Firestone building sits between the former sites of the Octopus ride and the go-cart track.

Edward Barber served as mayor of Bloomingdale from 1960 to 1964, ushering in many changes for Bloomingdale. He was in on the initial discussions of the Indian Lakes project when the Braniger Organization first wanted to come in and eliminate the sod farm on Schick Road and replace it with a golf course. (Courtesy of Amy Barber.)

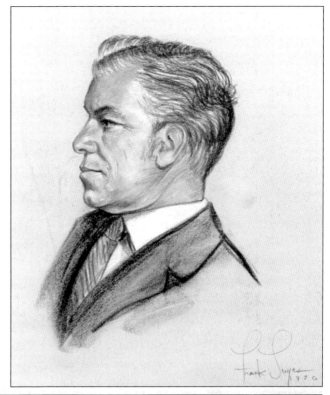

Dating back to the post-Civil War era on the north side of Lake Street west of Bloomingdale Road, the structure that was originally a harness shop eventually became a barbershop. The barbershop was still in business in 1957, as reported by a Bloomingdale resident who was getting his hair cut there when the Soviet Union launched the Sputnik program. During the 1980s, the vacant barbershop was moved across Lake Street into Old Town's parking lot, where it sat idle until the building was destroyed in 2003.

Both Evergreen and St. Paul Cemeteries date back to the 19th century and are located on the north side of Lake Street west of Glen Ellyn Road. In 1963, the two cemeteries were combined to become St. Paul Memorial Cemetery, which is cared for by St. Paul's Church. The cemetery contains seven graves from War of 1812 veterans and 32 graves of Civil War veterans. For years, the town commemorated Memorial Day with a parade to the cemetery. Since the mid-1990s, the Bloomingdale Historical Society has re-created the Memorial Day observance involving the Bloomingdale Veterans of Foreign Wars, local scouts, and other local organizations, along with patriotic music. The annual event is held in the cemetery, which is now referred to as St. Paul Evergreen Cemetery, and is well attended.

Bloomingdale School District 13's school, DuJardin Elementary, located at 166 south Euclid Avenue, opened its doors in 1964. The building is named in honor of Rosamond Neal DuJardin, an accomplished local children's author who published more than 100 works of writing. In her fiction for teenagers, she often used local scenes for settings in her books. DuJardin was the previous owner of the land on which the school stands; she sold the parcel to the district for the school. Her grandchildren attended the school. (Courtesy of Bloomingdale School District 13.)

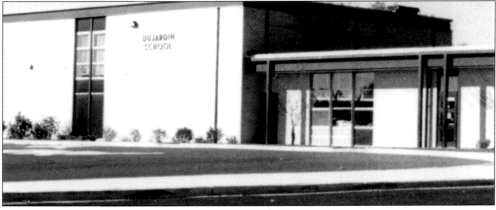

The Bloomingdale Park District came about because a core group of people worked very hard to put it together. The village of Bloomingdale created the Bloomingdale Park District by ordinance in 1963. In May 1964, a referendum was passed, 104 to 10, to establish a park district and elect commissioners. The former Bloomingdale township building at 108 South Bloomingdale Road was acquired and became the district recreation center until 1975 when it became the park district museum. In 1965, about 150 youngsters were registered in the limited activities. By 1969, more than 400 children were participating in more than 19 sports and organized events. In 1974, the park district hired Tom Lovern as a full-time director. Above is a photograph of the Bloomingdale Bears football and cheerleaders together from the 1970s. Below is a photograph of the Gulls girls' softball team, also from the 1970s. (Courtesy of the Morrisroe family.)

BLOOMINGDALE

Community Birthday Calendar TRADE MARK

An Adventure in Friendship to Make a Friendly Community More Friendly

SPONSORED BY BLOOMINGDALE BAND BOOSTERS

DEDICATED TO THE BLOOMINGDALE SCHOOL BAND

Hang this Birthday Calendar near your telephone and use it daily to remember and make happy one day in the lives of your friends in Your Community

The 1968 Bloomingdale school band community birthday calendar was designed by the district 13 band. The school band drew from the upper grades in the schools. The project had a two-fold purpose. It served as a fund-raiser for the band while it reminded residents of their friends' and neighbors' birthdays, stimulating a friendlier community.

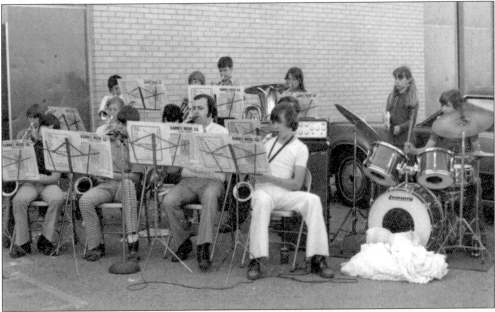

Here the Westfield Junior High band played at a Lions Club function called an "Elechick," which was part white elephant sale, part chicken dinner. The fund-raiser did not catch on, but the Lions Club had a great time putting on the event. Within the group of musicians playing is Rodger Himmel (second from the right in the first row), who was the band director at Westfield for many years. (Courtesy of the Bloomingdale Lions Club.)

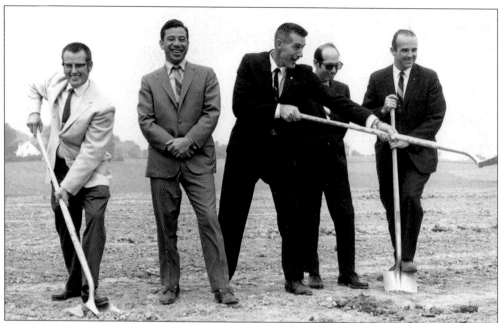

Village officials enthusiastically break ground for the Westlake subdivision in 1969, as the building boom started up in Bloomingdale. Pictured in the upper photograph holding shovels, from left to right, are trustees Wallace Geils, Ralph Johnston, and J. Stuart May. The other two gentlemen are from the development company Hoffman-Rosner. In the picture below, from left to right, are trustee Robert McLaughlin, village clerk Kay Funk, a Hoffman Rosner representative, and plan commissioners Robert Homola and Paul Monas. During the 1960s, Bloomingdale's population surged by 136 percent from 1,262 to 2,974. From 1970 to 1980, the increase was even more dramatic at 326 percent. The 1980 census marked Bloomingdale's population at 12,659.

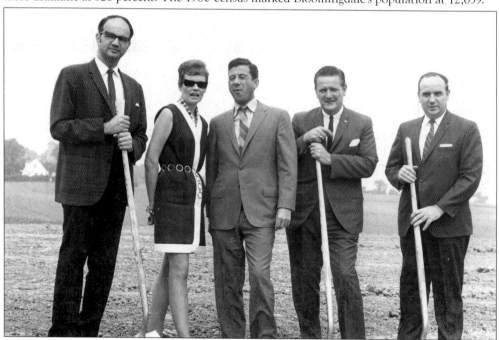

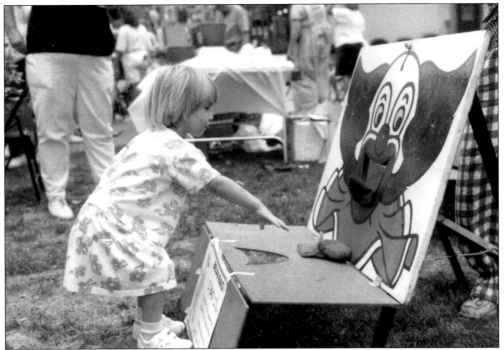

In Bloomingdale, Septemberfest is more than a fall beer garden. It is a neighborhood celebration wrapped around children trying their skills at game booths, an open house at the historical museum, arts and crafts, corn on the cob and other refreshments, and plenty of musical entertainment. The event has been an annual tradition the weekend after Labor Day since 1972.

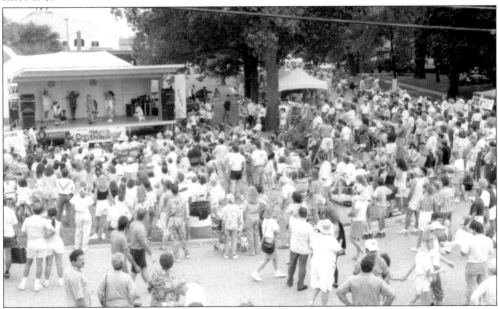

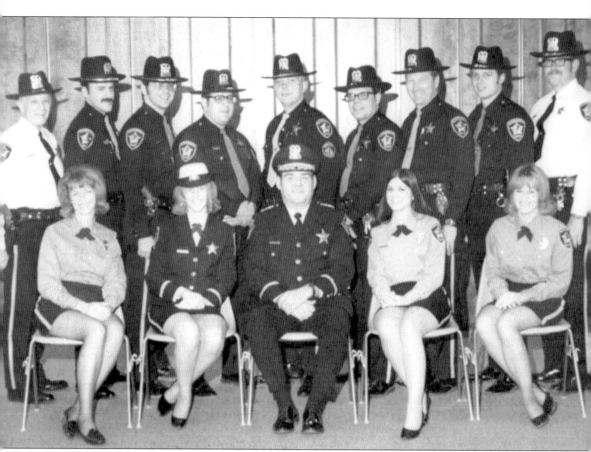

This is the Bloomingdale Police Department's first official picture taken in 1973 after the Bloomingdale Fire and Police Commission was formed. Once the town's population reached the 5,000 mark, by law, a commission had to be formed for the purpose of hiring, firing, discipline, promotion, and demotion for all sworn personnel. Prior to this, an officer was hired with a handshake. From left to right are (first row) unidentified, officer Shilora Larsen, Chief E. John Potempa, unidentified, and unidentified; (second row) Sgt. Charlie Bergman, officer Frank Yuro, officer David Raney, officer James Fiore, officer John Yisela, officer Charles Mader, officer Thomas Wagner, officer Gary Schira, and Sgt. William Hoak. (Courtesy of Charles J. Mader.)

According to David and Sharon Heil, owners of this property at 112 West Lake Street, there is a bit of a haunting story in this Old Town structure, which was originally a two-room house built in 1851. When the house was renovated, a stairway was removed; however, it is reported that one can still hear someone going up the stairs that no longer exist. Also items move around without explanation. The story goes that a person drowned in the well off the backyard. After a *Chicago Tribune* story appeared about ghostly occurrences, investigators thought the spirit frequenting Alltemp Fireplaces might be a child. (Courtesy of the Heil family.)

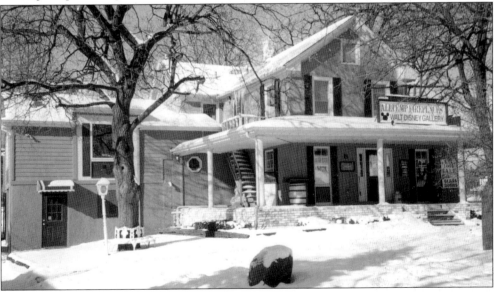

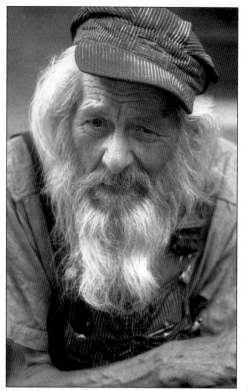

John Budd and his wife, Val, located here after they were married. Budd was originally enrolled in a premed program at the University of Illinois, but had to leave because of the Depression. He went on to be a wood-pattern maker. He was a very nice, intelligent man with a wonderful sense of humor. Budd was civic-minded; he served on the school board for a number of years. He and his wife were both active in Scouts. When his wife died suddenly from a heart attack, Budd always felt guilty that he did not recognize the signs that she was ill. When his well went dry he decided not to replace it. He stopped bathing and shaving, using borrowed water from neighbors only for coffee and flushing the toilet. He remained civic-minded, calling people regarding voting and other issues. He launched a successful write-in campaign to keep Diane McLaughlin on the school board, McLaughlin recalls. Budd was not a hermit, but he became more cautious about people he did not know. Ultimately, his house burned enough to be uninhabitable. Neighbors saw him out on Bloomingdale Road sitting in a chair watching the blaze. (Photographs by Thomas Derrico.)

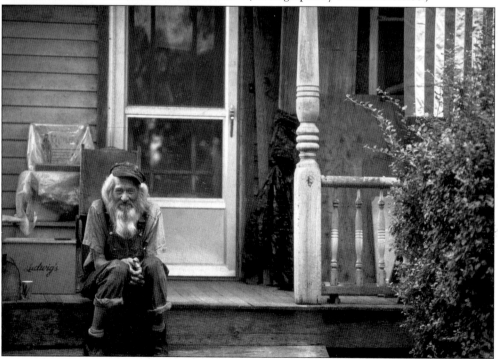

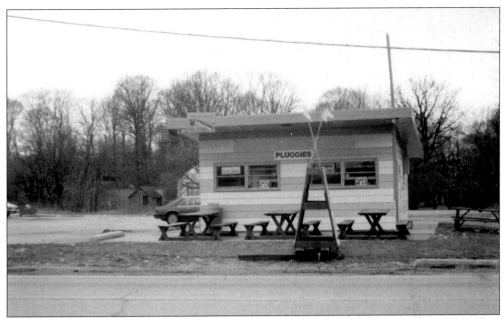

Pluggie's, a little hot dog stand located on north Bloomingdale Road, was a favorite of residents and business people alike. It never grew any larger than what is depicted in the photograph, although later it changed hands and names a few times. Even though the business survived the widening of Bloomingdale Road (Roselle Road) between Lake Street and Irving Park Road in the mid-1980s, the expansion of Turano Bakery later marked the demise of "the dogs to go."

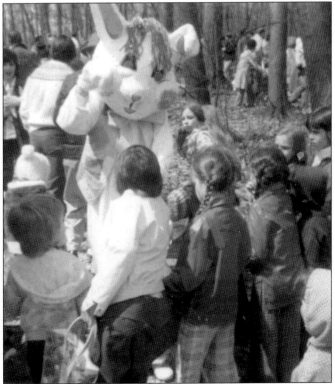

The Bloomingdale Women's and Bloomingdale Lions Clubs hosted an annual Easter egg hunt in Meacham Grove Forest Preserve. The event became so popular, it was eventually moved to Circle Park with its wide-open spaces. The Lions still continue the tradition with an Easter egg hunt for the little ones and an egg roll for the older children. (Courtesy of the Bloomingdale Lions Club.)

The Bloomingdale Public Library opened in 1975 with a 1,500-square-foot trailer at a cost of $3,000. The hours were part time, quarters were cramped, and the book collection was limited, but the village had its own library. Jean Hamilton (below), who was manning the phones back then, still works at the library part time.

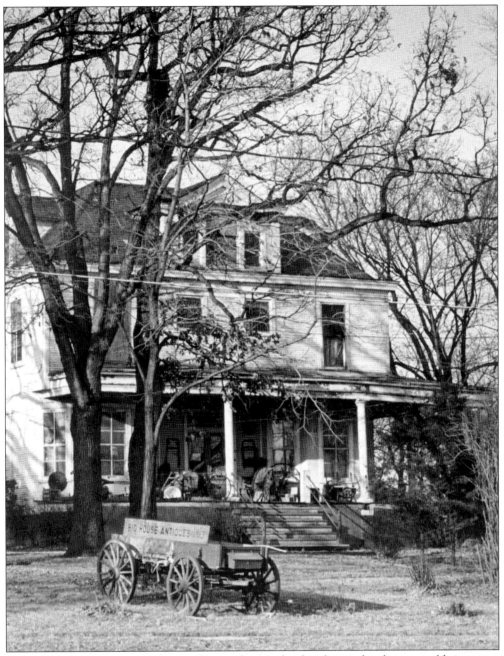

The Hollenbach house, which was ultra modern and palatial in its heyday, was sold sometime before 1917. It changed hands a few times and Charles Otto of Roselle leased it for an antique shop around 1975. He ran it for about five years before fire damaged the structure enough that it had to be demolished.

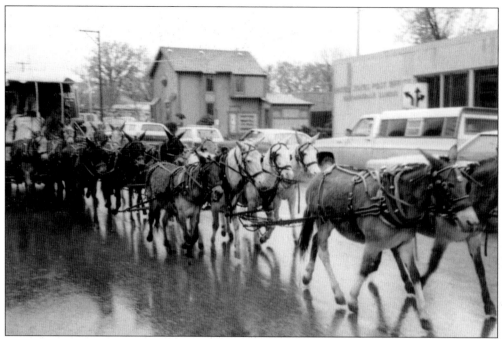

The bicentennial wagon train came through Bloomingdale traveling south on Bloomingdale Road. As part of the bicentennial parade that year, historical society member Marsha Franzen and her sons Craig (left) and Chuck rode in this covered wagon seen below. The society also converted the upper floor of the village hall on Lake Street back into an early-1900s classroom visited by the Central School students and the general public during that year. (Courtesy of the Franzen family.)

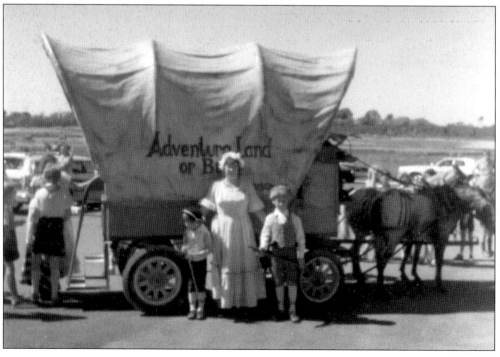

In 1974, Arthur Jakl and Associates, a Bloomingdale architectural firm, renovated this building at 107 South Bloomingdale Road. The firm decided it was cheaper to gut it than to tear it down and start over, so the building was taken down to the frame and floors before construction began. The original building dated back to 1849 and was sold to two Bloomingdale firms, Jakl and Associates and X-Cel Construction Company by Robert Smith. His father, Seth Smith, lived there after his grocery store burned in 1933. The building had been moved to this site from the corner of Bloomingdale Road and Franklin Street, where the post office was erected in 1962. This home is believed to have been the home of Robert F. Gates, Civil War veteran and Bloomingdale businessman.

In the 1980s, Bender's Hardware became an antiques store and still looked much like the original store with the bins and many fixtures to belie its hardware roots. The building still stands and is in use today, owned by financial planners, the Murphy Group.

For a number of years, the Bloomingdale Women's Club held a Festival of Arts in conjunction with the annual Septemberfest. It was a juried art fair and also had a craft section. It was held on the east side of Bloomingdale Road in the Bloomingdale State Bank's parking lot. Proceeds from this event were designated for the Bloomingdale Women's Club annual scholarship award program.

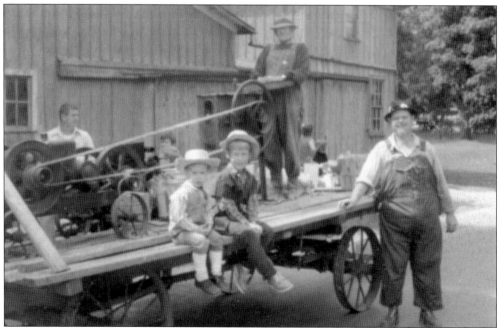

Herb Frick (right) brought his corn sheller to Septemberfest to show the youngsters how it works. Mr. Baine, Frick's father-in-law, accompanied him on this trip. The Frick farm was on the south side of Lake Street near Rosedale Road, and it originally stretched south all the way to Schick Road. Sitting on the wagon are Craig (left) and Chuck Franzen. (Courtesy of the Franzen family.)

Samuel J. Tenuto, a former village trustee, was elected mayor on September 18, 1979, in a special election. He set out a plan for "maintaining our unique community character, holding on tightly to our valued suburban environment, while flexing our financial muscle in commercial development." (Courtesy of Samuel J. Tenuto.)

The Marshall Field anchor store for Stratford Square mall was one of the first to be under construction.

The Bloomingdale Lions Club built the Lion Bob Homola Pavilion at Circle Park between Westfield Junior High and the park district pool to honor the memory of the late mayor and their fellow Lion. (Courtesy of the Bloomingdale Lions Club.)

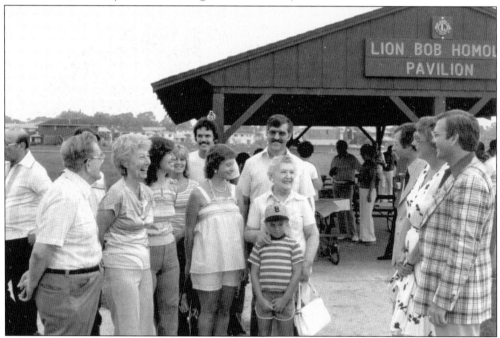

The pavilion dedication ceremony was held in summer 1980. Many of the late mayor's family members were in attendance. From left to right on the left side of the photograph are Bob Homola's father, Benjamin Homola; wife, Marilyn; daughter, Bonnie; nephew Mark Homola with his wife Carol; niece Debra Schaffer and her husband Ronald; mother, Elsie; and great-nephew Christopher Schaffer. Greeting the family are, from front to back, trustee Jim King, township supervisor Doris Karpiel, and Mayor Sam Tenuto. (Courtesy of the Bloomingdale Lions Club.)

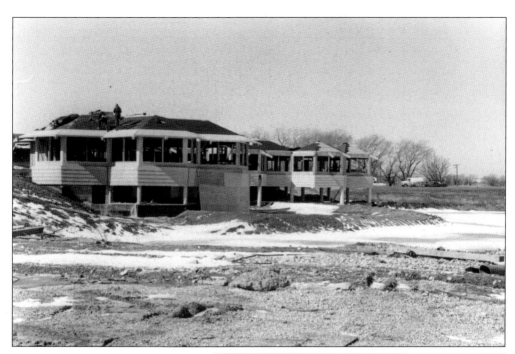

In the mid-1970s, Carson International, an enterprise of Carson Pirie Scott and Company, decided to buy the Indian Lakes Country Club property and build a resort. The facilities planned were to be much like the Carson Nordic Hills operation in nearby Itasca. The hotel was designed with several Frank Lloyd Wright–design features. Indian Lakes Resort opened its hotel doors on June 2, 1980. The first guests to sign the register were professional athletes who came to the resort for the 10th annual Brian Piccolo Cancer Research Fund Golf Outing held on June 3. With the addition of the hotel, the 260-acre facility was called Indian Lakes Resort. The 305 rooms and 23 guest suites all offered a view of either the surrounding landscape or of the open atrium with natural greenery and cascading fountain. The hotel complex is now known as the Hilton Chicago Indian Lakes Resort.

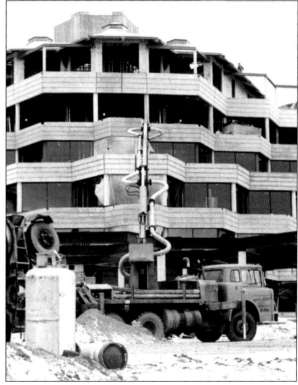

After decades of St. Paul and St. Isidore dominating the religious opportunities in Bloomingdale, other denominations began to offer more choices for residents. The Bloomingdale Alliance Church congregation began in 1978 with 21 people in the first service at Marquardt School on Glen Ellyn Road. The congregation grew, and by July 1979, it moved to the first building on the church's five-acre parcel on Glen Ellyn Road. Since then, the Bloomingdale Church has expanded greatly and is still under the pastoral guidance of senior pastor David Riemenschneider. (Courtesy of Bloomingdale Church.)

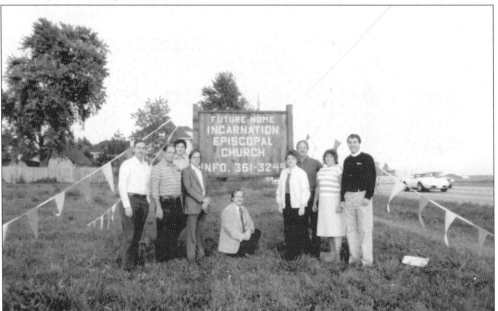

The Episcopal Church of the Incarnation was officially chartered on November 14, 1982. On that day, 112 individuals signed up as members of the congregation. Rev. Alvin Johnson was the fledgling church's pastor. The church began meeting at Central School and in time built a church on the north side of Army Trail Road near Skylark. Pictured here are Johnson (right) and members of the church with the "coming soon" sign. (Courtesy of the Episcopal Church of the Incarnation.)

Two of the renovated old homes that are part of the Old Town landscape are the Front Porch (above) at 124 West Lake Street and Grandma's Attic at 105 South Third Street. The Front Porch, a home accessories and handmade craft shop, opened in 1982 in the former home of the Petges family. Grandma's Attic, a children's clothing and accessories resale shop, was one of the first specialty shops in the Old Town area. The building was the home of Walter Petersohn, well known as the Bloomingdale township clerk for many years, as well as a long-standing village clerk. While both homes were retail establishments at the time, they have since been relegated to business uses.

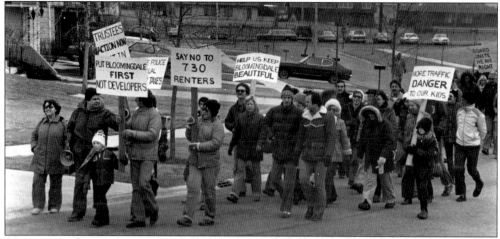

In 1979, Bloomingdale residents marched in protest of a proposed multistory apartment complex on a 15-acre parcel that would have brought over 700 rental units to the residential neighborhood just east of Bloomingdale Road on Schick Road. The Bloomingdale Plan Commission denied the project and the village board ultimately approved an alternate plan for town homes, greatly reducing the density. At the head of the marchers with megaphone in hand is William Horvath, who went on to win a seat on the village board in April 1981. He ultimately served as a trustee until April 1989.

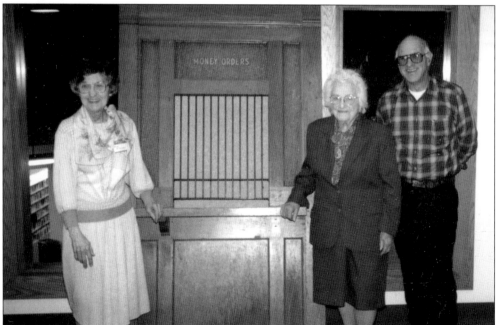

From left to right, Ethel Williamson, Laura Coppock, and Clayton Keller pose with the portable post office box. Each played an important role in the delivery of mail in Bloomingdale. Coppock worked full time as postmistress from 1955 until she retired in 1970. Williamson began as part time help for Coppock in 1956; when the postmistress retired, Williamson started putting in full days as "Officer in Charge." Village residents continued to pick up their mail at the post office until 1971 when home delivery was established. Former resident Clayton Keller had recently returned from service and he secured the job as the first mail carrier in Bloomingdale

In June 1983, the Bloomingdale Lions Club hosted its annual Half-a-Thon, dedicated to the memory of Mary Babyar, the wife of Lion Robert Babyar, who had passed away suddenly in 1981. The 1983 race drew almost 900 runners, which was up 122 percent over the previous year. One of the outstanding runners who took part in the race that year was Anne Clark, a 73-year-old retired schoolteacher from Glen Ellyn. Clark, who ran the full 13.1 miles, was considered to be the finest woman runner of her age. (Courtesy of the Bloomingdale Lions Club.)

STRATFORD SQUARE

BLOOMINGDALE · NORTHWEST OF CHICAGO

Six Majors, Spectacular Shopping!

Stratford Square Mall opened on March 9, 1981, to much fanfare. An invitation-only sneak preview dinner was hosted the evening before, along with entertainment throughout the mall. The 1.4-million-square-foot shopping center was located on a 96-acre site beginning at the southeast corner of Schick Road and Gary Avenue. One hundred of a possible 180 stores were open that first day, including the four anchors, Marshall Field, Carson Pirie Scott, Montgomery Ward, and Weiboldt. The opening of this commercial venture marked the beginning of an era of a stronger financial situation for the village and an enviable position for planned and well-designed growth. (Courtesy of Samuel J. Tenuto.)

Introducing the dazzling new world of Stratford Square!

Expect to be surprised. Excited. Everything you think you know about shopping centers will change when you come to Stratford Square, the most spectacular new shopping, dining and entertainment center to open in America! Walk into the beauty of spring, no matter what the weather's like outside and be greeted by skylights reaching to the sun, cascading waterfalls, reflecting pools filled with natural marsh grasses, massive ficus trees and green and blooming plants everywhere. The warmth of beautiful earthtone woods, natural redwood beams and hand-crafted tiles combine to welcome you into the fabulous worlds…day and night…of Stratford Square. It's *THE* place in the western suburbs for superb shopping, dining and entertainment.

Dine…

in the exciting Festival Court surrounded by a wonderland of flowers, trees, water falls and reflecting pools. Relax at an "outdoor cafe" (though you're really inside!), enjoy a quick snack or dine at one of our full-service restaurants. During the day, while shopping or in the evening (even after the rest of the shopping center is closed) you'll be able to enjoy everything in the Festival Court.

Shop…

at all your favorite stores—Marshall Field's, Carson Pirie Scott & Co., Montgomery Ward and Wieboldt's are now open. More than 180 stores will soon be here, with as many as 100 open right now. You'll find all your favorite stores for everything you want and need for Spring for you, your family and your home. An exciting new shopping experience awaits you at Stratford Square.

Stratford Square

And on into the P.M.…

Enter the night-time world of Stratford Square where you'll find *four* Plitt movie theatres. The magic of Festival Court at night, after the rest of the shopping center has closed, is a unique entertainment experience. Shops and specialty food stores, as well as the many dining facilities in Festival Court will be open. You can shop thru early evening and be entertained late into the evening in Stratford's P.M. Festival Court.

In west suburban Bloomingdale, at Gary Avenue, ½ mile north of Army Trail Road.

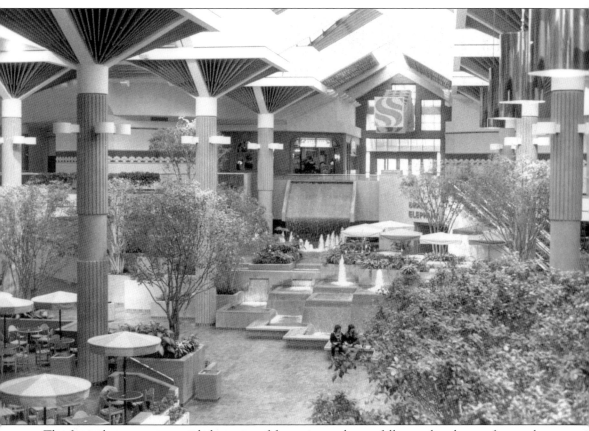

The festival court area provided a series of fountains and waterfalls, an abundance of natural lighting, and a spacious, appetizing food court.

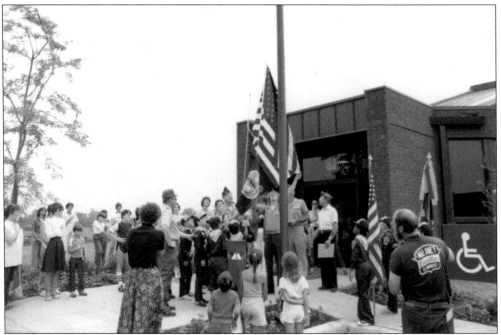

On July 15, 1982, the Bloomingdale Public Library opened the doors to its 12,000-square-foot facility just 12 months after construction began and only two percent over budget. With the additional space, many more items could be added to the collection, and more programs for adults and children could be accommodated. The community was ecstatic; it was a long time coming.

Franz Bentler and his orchestra were part of the entertainment for the Bloomingdale Founders' Festival Dinner Auction held in October 1982. They played in festival court at the Stratford Square Mall. This was the only fund-raiser hosted by the village to earn money toward the sesquicentennial gazebo to be built and for some of the many events that were planned for the yearlong celebration during 1983.

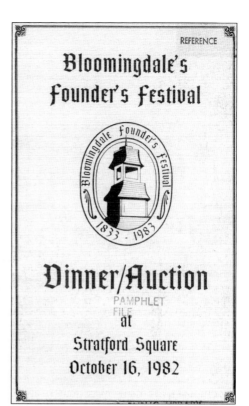

Bloomingdale's Founder's Festival

Dinner/Auction

at

Stratford Square
October 16, 1982

Among the many guests for the fund-raiser were, from left to right, unidentified guest, village attorney Ronald S. Cope, Mayor Samuel J. Tenuto, and Congressman Henry Hyde, sixth congressional district.

As part of the sesquicentennial festivities, the village board passed an ordinance that all men had to grow a beard in honor of the anniversary. On March 5, 1983, a beard court was held and whiskerless men were charged $1.98 for failure to comply. Here from left to right are defense attorney Marvin Roehlke, persecuting attorney Paul Conarty, and bailiff James Sargis, who all search trustee Roy Brodersen's face (in vain) to see any stubble. Notice the noose in the upper right-hand corner of the photograph. (Courtesy of the Sargis family.)

The village board members put themselves on the auction block in 1982 to raise funds for the sesquicentennial. They offered an evening of entertainment at a private party as the "Village People." Kneeling are trustees James LeBurkien (left) and Robert Iden. Standing from left to right are trustee Roy Brodersen, Mayor Samuel J. Tenuto, trustee James Horvath, and trustee Walter Cropper.